Digital Photography
Pocket Guide

Also available from O'Reilly:

Digital Video Pocket Guide
Digital Photography Hacks

THIRD EDITION

Digital Photography
Pocket Guide

Derrick Story

O'REILLY®

Beijing • Cambridge • Farnham • Köln
Paris • Sebastopol • Taipei • Tokyo

Digital Photography Pocket Guide, Third Edition

by Derrick Story

Copyright © 2005, 2004, 2003 O'Reilly Media, Inc. All rights reserved.
Printed in the United States of America.

Published by O'Reilly Media, Inc., 1005 Gravenstein Highway North,
Sebastopol, CA 95472.

O'Reilly books may be purchased for educational, business, or sales promotional use. Online editions are also available for most titles (*safari.oreilly.com*).
For more information, contact our corporate/institutional sales department:
800-998-9938 or *corporate@oreilly.com*.

Editor:	Colleen Wheeler
Production Editor:	Genevieve d'Entremont
Cover Designer:	Mike Kohnke
Interior Designer:	Marcia Friedman
Photographer:	Derrick Story

Print History:

July 2003:	First Edition.
November 2003:	Second Edition.
August 2005:	Third Edition.

ISBN: 0-596-10015-9
[DS]

This book is dedicated to Galen Rowell,
who achieved critical acclaim shooting landscape
photography with a 35mm camera.

By doing so, he opened museum and gallery doors to
all small format and digital photographers who want to
display the timeless beauty of nature, but prefer to use
modern tools instead of traditional large format cameras.
Galen and his wife Barbara died in a plane crash
on August 11, 2002 in Inyo County, California.

Contents

3. 📷 How Do I...? 87

Who's in Charge?

When you first pick up a digital camera and hold it in your hands, many thoughts go through your head. Initially, you might simply wonder where the power button is, or how to turn on the LCD monitor.

Soon, you reach a crossroads with two options before you. The first is to just take what you've learned about your camera in the first few minutes, and use that knowledge to take the best pictures you can. If you go down this path, the camera is merely an acquaintance. It is in charge, and it does the best it can to help you capture snapshots on vacation or at birthday parties. In return, you try not to drop it and maybe even occasionally clean its lens.

The other path is much different. The first few steps are the steps that everyone takes with a new camera. "How do I make the lens zoom?" "Where's the battery compartment?" But after a short while, you find yourself in territories previously unknown. You begin to wonder, "How can I take a close-up of that flower?" or "Can I shoot a portrait at twilight?"

This book is a friendly guide for those who want to take the second path. If you go down this road, you and your camera will become close friends. You'll get to know every feature and

learn how they can help you make outstanding images. In a sense, your camera will become an extension of your vision— and that means you're the one making the decisions, not the camera.

Chapter 1, What Is It? The adventure begins like preparations for any vacation. You have to account for everything that's going to accompany you and know where it is. In Chapter 1, you'll learn about every nook and cranny on your camera. Or, if you haven't purchased one yet, you'll discover the features you need and—just as important— the ones you don't.

Keep your owner's manual handy when you first review Chapter 1. It will help you find where the flash control button is located on your particular model, for instance. Once you find it, this book will show you how to use the different flash modes to take the pictures *you want*, not the ones the camera dictates.

Think of Chapter 1 as a detailed map. It tells you where things are and a little about what they do. It's designed for quick reference—answers while on the road—so make sure you keep this book with you. It's designed to fit easily in your camera bag or your back pocket.

Chapter 2, What Does It Do? By now, you've located the flash button on your camera, and you've even read about the different modes available, such as *fill flash* and *slow synchro*. Terrific. Now, when do you use fill flash? What is slow synchro good for?

Chapter 2 will help you answer those questions. You're now well on your way to becoming close friends with your camera, and while you might not notice it, you've taken control of the situation. In the beginning, the camera

made all the decisions. Most of the time they were adequate, but now you're in charge, and your pictures are much better as a result.

Chapter 3, How Do I…? Here you'll learn more than a dozen important camera techniques. How do you take great outdoor portraits? How can you shoot architecture like a pro? Can you take action shots with a consumer digital camera? Chapter 3 is like an ongoing conversation between two old fishing partners, discussing the best approaches to a variety of situations.

By the time you've experimented with the techniques outlined in this pocket reference, you'll have journeyed well beyond others who chose the first path. Soon you'll be able to visualize how pictures should look in your mind, and then be able to make the camera capture those images so you can share them with others. Isn't that what photography is all about—showing others the world as you see it?

The difference between these two paths is *control*. So, who's in charge: you, or the camera?

What's New in This Third Edition?

Digital photography has become even more exciting since I wrote the previous edition of this guide. For example, it's now easier than ever to connect your camera directly to a portable printer, bypassing a computer, and produce 4" × 6" snapshots. So if you love sharing pictures but hate computers, digital photography is for you too.

To help you understand how this computerless connection works, I've added descriptions on PictBridge and Direct Printing. That way, when you shop for your next camera and printer, you'll know to look for these features.

Another improvement we've seen in digital cameras is their ability to capture high-quality movies. Earlier models enabled you to record small, jerky video. Many of today's cameras let you capture full-motion, full-frame video with high-quality sound.

I've added discussions about how to manage these mini-movies on your computer, and even provided tips for editing them into short feature presentations. Thanks to this leap forward in technology, you can now pack just one compact camera and capture both still pictures and movies.

All of the specifications in this guide have been updated, too—everything from new formats, such as DNG and MPEG-4, to cameras with more megapixels requiring bigger memory cards.

Finally, you'll notice that I've taken extra care with the illustrations. Most of them are brand new to this edition. I want to make it as easy as possible for you to master digital photography, and that means that the pictures in this guide have to be as informative as the words that accompany them.

So let's get to taking great shots!

What Is It?
A Tour of Your Digital Camera

Camera makers have packed amazing capability into today's digital picture takers. The camera that you have in your hands, or the one that you're considering buying, probably has more ability than you realize. The trick is, how do you discover that hidden potential?

The first steps are to become familiar with your camera's components, and then to learn exactly what they do. This chapter helps you do just that. It explains the important components and features that will set you on the path to mastering your digital camera.

If you're just getting started with digital photography, this information can also help you pick the right model. I like to divide digital cameras into four broad categories: *compact*, *advanced amateur*, *professional*, and *hybrid*. As you progress through the first three categories, you'll find that the tools become more sophisticated. The fourth category, hybrid, is an example of how digital imaging is converging with other technologies. These devices can be quite useful, but they won't usually serve as your primary camera.

We'll begin with an overview of the features and components that are commonly found in compact digital cameras. I spend more time on the compact because it is the camera that I

think every photographer—from first-time beginner to seasoned pro—should have in his or her bag of tricks, regardless of what other tools you use. In many ways, the compact camera defines digital photography itself. It is powerful, yet easy to use.

Later in the chapter, we'll spend some time with the more advanced camera categories. This is where I discuss image sensors, lens specifications, and other components. If you enjoy technical talk, then you'll like the latter half of the chapter. If not, read the compact camera section and jump to Chapter 2. No matter what your level of interest is, I have lots here for you to explore.

Overview of Camera Categories

In many ways, cameras are as varied and unique as the people who use them (Figure 1-1).

Figure 1-1. Today's digital cameras are as varied as the people who use them

But in order to help you decide which models are potentially a good fit for you, I've grouped them into four basic categories. Here's a quick summary of each one:

Compact Compact cameras are perfect companions for vacationers, parents, and photographers constantly on the go. Because compacts fit easily into purses, backpacks, diaper bags, briefcases, and even shirt pockets, the odds are good that you'll have a camera on hand as life unfolds before you. That's why I recommend that all photographers should pack a compact, regardless of any other cameras they have in their arsenals.

These pint-sized wonders do have their trade-offs. The zoom lens typically tops out at 3× magnification, so your ability to "zoom in" tightly on distant subjects is limited. It's also more difficult to add accessories to compacts, such as filters, auxiliary lenses, and external flashes.

Happily, though, megapixel power is no longer a trade-off for portability. Most compacts these days provide at least a 3-megapixel sensor, and 5-megapixel models have become commonplace. This is more than enough resolution for snapshots and moderate enlargements. Compacts usually cost less than $400.

Advanced amateur For photographers who want professional capabilities but aren't ready to commit to the costs and bulk that come with camera bags brimming with expensive gear, advanced amateur models are a satisfying compromise. These cameras are typically more compact than digital SLRs (see the description of professional cameras, next), yet often provide a variety of camera modes, powerful zoom lenses (up to 10×), hefty image sensors (8 megapixels or more), and the capacity to accept a variety of accessories, including filters, auxiliary lenses, and external flashes.

Advanced amateur models often excel at capturing digital video in addition to still images, and they often have variable-angle viewfinders that allow you to hold the

camera above your head or below your waist and still compose the picture. Finally, advanced amateur cameras often provide the option for RAW format image capture, which enables you to delay processing of the image until later, on your computer. Advanced amateur models range from $500 to $800.

Professional Just because you don't earn your living taking pictures doesn't mean you don't want the capabilities that pros require in a camera. The star of this category is the *digital single lens reflex* (DSLR), which looks similar to the 35mm SLRs that pros and amateurs have been toting around for years.

DSLRs enable you to quickly switch from one type of lens to another by simply removing the lens from the camera body and attaching another. With dozens and dozens of optics to choose from, this provides tremendous flexibility. Another feature is that you compose your picture through the same lens that captures it. "What you see is what you get" with DSLRs.

Inside the camera body, manufactures have packed sophisticated electronics to enable you to capture pictures quickly (with virtually no shutter lag), in rapid sequence (burst modes of a dozen pictures or more are not uncommon), and with unparalleled image quality, both in terms of megapixels and noise reduction. RAW mode is a standard feature for DSLRs.

Often, you can add wireless external flashes, WiFi image-transfer capabilities, and a host of sophisticated accessories that include remote releases and macro lighting rigs. DSLRs start at around $900 and can quickly escalate to a few thousand dollars—and keep in mind that optics and accessories add to the bottom line.

Hybrid devices As digital imaging components become smaller and more energy efficient, technology companies are able to incorporate them into ever more and different types of devices. You can now buy a mobile phone that also has megapixel picture-taking capabilities, and many digital camcorders include multi-megapixel sensors, memory cards, and even electronic flashes.

Most photographers would not rely on camera phones or digital camcorders as their primary picture-taking devices. But as the technology evolves, these tools can become useful additions to your ever-broadening arsenal of imaging devices.

Feature and Component Comparisons

Even the simplest digital camera has more features than you realize, some of which you may actually want to use. I'll start this section with a tour of a typical compact camera, highlighting useful components on the front, back, sides, and inside.

More detailed discussions about image sensors and lenses follow, in the "Advanced Amateur Cameras" and "Professional Cameras" sections.

Anatomy of a Compact Camera

Form factor is a primary consideration when shopping for a compact camera. Is it small enough to accompany you during your daily life? You've wasted your money if your point-and-shoot is at home on the dresser when your child takes his first steps at grandma's house. These devices are intended to fit in our purses, backpacks, briefcases, jacket pockets, and bike bags—make sure the camera you want fits in your typical carryall.

Next, consider how you're going to view your pictures. If your primary method of sharing is via the computer—email attachments, slide shows, and web pages—your camera of choice should be compatible with the computer you already have. Ideally, you should be able to connect your camera and let the software you use recognize the camera and offer to upload the pictures.

Many photographers prefer prints and aren't as interested in digital manipulation. If you feel the same way, look for a compact camera that makes it easy to connect directly to a printer and produce 4" × 6" prints (or larger, if you prefer). You don't need a computer to enjoy digital photography, and there are some great compact printers out there.

Pocket cameras have also become quite adept at capturing video. You may not be using this function right now, but I hope to inspire you to capture movies as well as still photographs. Sometimes a video clip is worth a thousand pictures—isn't that how the saying goes? When the best man gives that perfect toast, you want to have your digicam in movie mode. But video capabilities vary greatly from model to model, so this is something to add to your checklist of features to compare.

Finally, figure out how much you can spend on your point-and-shoot, add the cost for a spare battery and memory card and a dedicated printer (if that's how you plan to share your images), and then study the following features lineup. With a little research, you'll be able to find the right compact for you at a cost you can afford.

Once you settle on the right compact camera, spend some time with the owner's manual to become familiar with its unique design and how to use its controls. After studying the manual, keep this guide in your camera bag—not only does it provide a quick reference for the major components, but it will also help you understand how to use those features to take better pictures.

In the next sections, I'll show you the basic features you'll find on a compact camera. I've organized the list based on where each feature is typically found, although each camera model may vary slightly. Figure 1-2 shows the features you'll usually find on the front of a compact camera. Figure 1-3 shows the back panel of a compact camera. Figure 1-4 shows the top side of a compact camera, where items such as the shutter button, zoom, and power button are typically found. Figure 1-5 is your signpost to the discussion about the components inside of the camera.

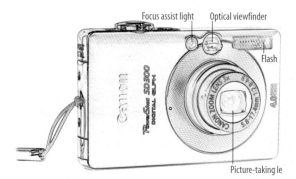

Figure 1-2. The front of a compact camera

Flash

The flash provides additional light for pictures taken indoors or at night, and for outdoor portraits. Look for flash controls that are quickly accessible and not buried deep within a menu system.

Focus assist light

The focus assist light helps your camera focus in dim lighting by projecting a white beam, or a subtle pattern, onto the subject. This light may also shine when you're using the red eye reduction flash mode and serve as the warning light when the self-timer is activated.

Microphone port

A tiny opening on the front of the camera is used to record audio annotations and to add sound to movie clips. Some cameras that have a *movie mode* also have built-in microphones, but not all do.

Optical viewfinder lens

The optical viewfinder lens enables you to compose the picture by looking through the viewfinder lens instead of viewing the LCD monitor on the back of the camera. Using the optical viewfinder saves battery power, but it isn't quite as accurate for framing precise compositions or close-ups.

Picture-taking lens

The picture-taking lens projects the image you're shooting onto the electronic sensor where the picture is recorded. This lens also captures the image you see on the LCD monitor on the back of the camera.

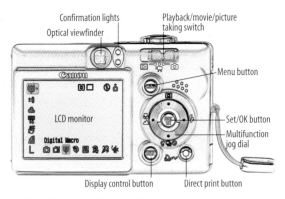

Figure 1-3. Back panel of a compact camera

Confirmation light

The confirmation light shines when the camera is focused and ready to fire, or when the flash is ready. Blinking indicator lights usually suggest that you need to make an adjustment before taking the picture.

Display control button

You can turn off the display to conserve battery power. This button often has a third option that provides for the display of camera data on the screen while composing the picture. You can typically cycle through these different settings by pushing the button repeatedly.

LCD monitor

The LCD monitor allows for precise framing of the subject, because the image is captured directly through the picture-taking lens. You should always use the LCD monitor in macro mode (for close-ups). The LCD monitor is also used for reviewing pictures you've already captured. Most LCD monitors, however, aren't effective in direct sunlight—the image is hard to see. If you shoot lots of outdoor pictures, make sure your camera has an optical viewfinder as well. Camera manufacturers are also starting to provide models with 2" (measured diagonally) or bigger LCD viewfinders. If you spend more time viewing your images on the camera than on a computer, you should give the size of your camera's LCD monitor important consideration.

> **NOTE**
>
> Most of the important functions are accessible via buttons to the right of the LCD monitor. This is an important design feature to consider when choosing a digicam, because buttons and dials allow you to make quick camera adjustments—using them is much faster than scrolling through menus on the LCD monitor.

Menu button

The menu button activates the onscreen menu that enables you to set the various functions of the camera. Most likely, you'll use the multifunctional jog dial to navigate through those menus.

Mode dial

The mode dial allows you to switch among various picture-taking and picture-reviewing modes.

Multifunctional jog dial

The multifunctional jog dial allows you to navigate through onscreen menus by pressing the four directional buttons. Sometimes, jog dial buttons have two sets of functions: one set for changing settings while in picture-taking mode, and the other for making adjustments in picture-viewing mode. Look for little icons next to the jog dial buttons. These icons usually represent the functions associated with those buttons in picture-taking mode. Here are a few of the most common ones:

Burst This setting enables you to take a sequence of shots by holding down the shutter button.

Close-up Sometimes called *macro mode*, this setting allows you to focus your camera on subjects that are only inches away.

Flash modes All digital cameras provide you with flash options, such as flash on, flash off, and red eye reduction. This button allows you to cycle through those options and choose the best one for the situation at hand.

Metering modes Some cameras provide more than one metering mode, such as *evaluative* and *spot* (see the discussion of exposure metering options in the "Advanced Amateur Cameras" section). You can choose which mode you use via this control.

Self-timer Use this function to delay the shutter firing for a few seconds after you've pressed the shutter release button.

Set/OK button

Press the set/OK button to confirm a choice. Most cameras insist that you confirm all selections before enabling them. This button is particularly important when erasing pictures, as it makes it impossible to delete a picture by inadvertently pressing the erase button.

Trash button

Pressing the trash button removes the current picture displayed on the LCD monitor. This button doesn't usually remove all pictures on a memory card; for that, you have to select the "erase all" function via the onscreen menu.

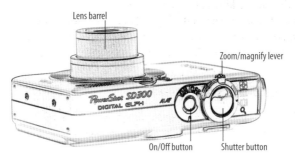

Figure 1-4. Top side of a compact camera

Computer connection

The computer connection is used for transferring pictures from camera to computer. Most cameras provide a Universal Serial Bus (USB) cable to make this connection.

Shutter button

The shutter button trips the shutter, but it also provides focus and exposure lock. For the best pictures, press lightly on the

shutter button and hold it in the halfway position to lock the focus and exposure. Once the confirmation light comes on, you're ready to take the picture. Then add more pressure until the shutter trips. The trick is to not let up on the shutter button once the focus is locked, but to keep the pressure on in the halfway position until the exposure is made. Almost all digital cameras use this type of two-step shutter button.

A handy tip to ensure that the camera focuses on the area you want is to point the camera directly at what's most important, hold the shutter button down halfway, recompose the picture, and then depress the shutter button the rest of the way to make the exposure.

Tripod socket

The tripod socket allows you to attach the camera to a tripod or flash bracket. Metal sockets are more durable and therefore superior to plastic ones.

Video out connection

The video out connection allows you to connect the camera directly to a television or other monitor to display pictures on a larger screen. Using video out is an easy way to show your pictures to a large group of people.

Zoom/magnify lever

Use the zoom/magifiy lever to zoom in and out when composing your image in picture-taking mode. (Your camera may have buttons instead, but they work the same way.) When in picture-review mode, this lever also allows you to magnify your image on the LCD monitor for closer inspection.

Battery

The battery provides the power for camera functions. This is one feature that every digital camera must have. Common

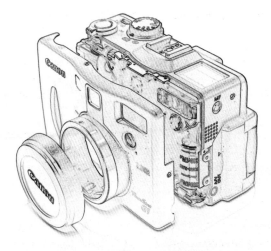

Figure 1-5. Inside view of a digital camera

battery types are alkaline (for emergencies only), lithium-ion, and nickel-metal hydride. The latter two are rechargeable.

(See the "Advanced Amateur Cameras" section for a more in-depth discussion of battery types.)

Direct Print

Direct Print is a standard developed in 2002 that enables a common printing protocol between camera and printer, eliminating the need for a computer to produce prints. Original adopters were Canon, Epson, Fujifilm, HP, Olympus, and Sony. Many consumer cameras use an evolution of this technology called PictBridge (discussed later in this chapter).

Image sensor

The image sensor converts light energy passing through the camera lens into a digital signal. Sensor capacity is measured

in *megapixels*. Look for a compact with at least a 3-megapixel sensor.

Memory card

Memory cards store the picture data captured by your camera. Nearly every digital camera contains some type of removable memory. When the camera takes a picture and creates the data for that image, it "writes" that information on the memory card. This enables you to retrieve or transfer your electronic pictures long after they've been recorded.

Table 1-1 can help you determine the best memory capacity for your camera, based on its megapixels.

NOTE

For a more in-depth consideration of the types of memory, see the section "Advanced Amateur Cameras." To get a general sense of how megabytes translate into numbers of pictures, see Table A-8 in the Appendix.

Table 1-1. Minimum and recommended digicam memory cards

Camera type (megapixels)	3 MP	4–5 MP	6 MP and up
Minimum card	256 MB	512 MB	1 GB
Recommended card	512 MB	1 GB	2 GB

PictBridge

PictBridge enables direct printing from your digital camera to a printer. You simply view an image on your camera's LCD viewfinder and select "print," and the camera sends the required data to the printer via the USB cable. This eliminates

the need for a computer and photo-editing software to produce prints. Both the camera and printer must support Pict-Bridge for this to work.

RAM buffer

The RAM buffer stores image data in the camera's Random Access Memory (RAM) before transferring it to the memory card. The RAM buffer enables advanced functionality, such as burst and movie modes. The camera can move picture data to the RAM buffer much faster than it can write data to the memory card. So when you use burst mode, for example, the camera captures a sequence of shots in the RAM buffer, then transfers the data to the memory card after you've released the shutter button. RAM buffers can be as large as 32 MB. The larger the buffer, the longer your shot sequences can be.

USB Mass Storage

USB Mass Storage device connectivity enables the camera to connect to a computer without using any special drivers, much in the same way that you mount an external hard drive by plugging it in. You can then "drag and drop" your pictures from the camera to the computer, or use an image application to download them.

Digital cameras that are USB Mass Storage devices can be connected to computers running the following operating systems without installing any special software: Windows XP, 2000, ME, and 98 SE, plus Mac OS 9.x and Mac OS X 10.1 or later.

Advanced Amateur Cameras

Today's advanced amateur digital cameras are reminiscent of film rangefinder classics such as the Leica M6. Whether classic or modern, these cameras appeal to serious photographers who want to pack as much quality and control as possible into a camera that hangs lightly around the neck.

Advanced amateur cameras feature high-quality zoom lenses, 6-megapixel or higher image sensors, and an array of controls that will help you meet just about any photographic challenge. You can usually build an entire outfit, including flash and accessories, for less than $1,000.

These tools are for photographers who like the art and science of photography, so in this section I'll spend a little more time talking about various aspects of these cameras, to help you understand their capabilities.

Battery types

If your camera came with alkaline AA batteries, use them for testing, then replace them as soon as possible with rechargeable nickel-metal hydride (NiMH) batteries, which last much longer than alkalines and will save you lots of money over time. It's always good, however, to keep a fresh set of alkalines handy in case your NiMHs run out of juice while you're away from the charger. Another good practice is to have two sets of the rechargeables, so one's always ready to use—they're a little expensive at first, but much cheaper than buying new alkalines over and over.

Lithium-ions are very popular with major camera makers such as Sony, Nikon, and Canon. Most of these cameras come with their own proprietary battery and its matching charger. Lithium-ions typically have great capacity and hold their charge for a long time, but you might want to buy an extra battery—you can't use readily available alkalines as a backup.

Another thing to keep an eye out for with lithiums is *how* you charge the battery. I recommend using a separate charger (the more compact the better), instead of having to recharge the battery by plugging a power adapter into the camera. Obviously, you can't pop in a spare battery and go out and take pictures if you need to plug your camera into a wall socket to recharge.

Diopter adjustment

The diopter adjustment allows for manual adjustment of the optical viewfinder to best suit your vision. When I was younger, I could care less about this feature. These days I'm very thankful for it, because it's hard to look through optical viewfinders with glasses on.

Exposure metering options

All digital cameras have some type of exposure meter, but many models have more than one *pattern* for measuring light. The three most common patterns are:

Center-weighted The meter measures light levels in the entire picture area, with extra emphasis placed on subjects in the center of the frame.

Evaluative The image area is divided into sections (usually six or more), and light is measured in each section. The camera then "evaluates" each section and matches the overall pattern to data stored in its computer system. The resulting camera settings are determined by how the pattern and data match up.

Spot To determine the exposure, light is measured in only the center area of the viewing area, usually indicated by brackets. Everything else is ignored. Spot metering is helpful in contrast lighting situations that might fool other metering patterns.

Advanced cameras may include all three of these metering patterns, while more basic models may rely on only the evaluative pattern.

Many of the features that distinguish an advanced amateur camera are found on the top of the camera, shown in Figure 1-6.

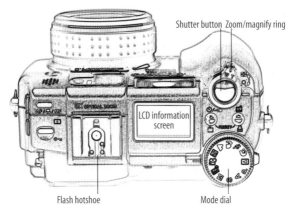

Figure 1-6. The top of a typical advanced amateur camera

Hotshoe

The hotshoe provides a connection for an external flash and other camera accessories. The metal contacts allow the camera to communicate with the flash to provide advanced features such as dedicated exposure control. Often, you can purchase "dedicated flash cords" that enable you to retain communication between camera and flash, but move the two apart for more lighting options. One end of the cord connects to the hotshoe, and the other connects to the base of the flash.

Image stabilizer

Often referred to as "anti-shake technology," the image stabilizer helps you capture sharp pictures in low light. When activated, the camera actually compensates for the minute movements you make during exposure. Camera shake creates a picture that looks "soft" and not quite in focus. By counteracting those minute movements, image stabilizers help you record sharper images.

Infrared sensor

The infrared sensor is primarily used to communicate with the remote control release for cameras that have that capability.

LCD viewfinders that swivel

Most compacts and DSLRs have LCD viewfinders that are fixed-mounted to the back of the camera. An advantage you often find with advanced amateur models is an LCD monitor that swivels away from the back of the camera. This enables you to hold the camera at a variety of angles and still compose the picture—perfect for taking "over the head" shots at a parade!

Memory card options

The most popular memory cards are CompactFlash (CF) and Secure Digital (SD), but Sony Memory Stick (MS), IBM MicroDrive, MultimediaCard (MMC), and the xD-Picture Card introduced by Fuji and Olympus are also widely used. Some older cameras use SmartMedia (SM) cards, which are still available but are not as easy to find as they used to be. That technology is being replaced by xD-Picture Cards and SD cards, which are smaller and have more capacity.

The type of memory card your digicam accepts isn't as important as its capacity and performance. Most cameras ship with *starter memory cards* that hold only 16 or 32 MB. These are fine during the learning phase, but once you're ready to take your camera on vacation or photograph your daughter's birthday party, you'll need more memory. Some cameras don't even provide a memory card in the box. Make sure you have a compatible one on hand, or you'll be sorely disappointed.

Another thing to consider when shopping for memory cards is the speed at which they read and write. "High-speed" or "ultra" cards can perform at many times the speed of "standard" cards,

but much of this benefit depends on the sophistication of your camera's electronics. If you have a high-performance camera, you should consider having at least one high-speed memory card. Standard cards should perform just fine for basic models.

Remote release

The remote release allows firing of the camera from distances of up to 15 feet. Some remote releases also allow you to operate the zoom lens. For best results, point the sensor on the remote release at the infrared sensor on the front of the camera.

Zoom lenses

Camera makers tend to list two sets of numbers on the barrel of the lens, or on the body near it. The first set is usually followed by "mm" (which stands for "millimeters") and looks something like this:

5.4–10.8mm or *7–21mm*

These numbers represent the *zooming range* of your lens. Most consumer digital cameras have a zooming range of 3×, such as a 7–21mm lens.

If you're familiar with 35mm photography, you can translate those digital camera focal lengths into terms that are easier to understand. For example, a 7–21mm zoom lens in the digital world is the rough equivalent of a 35–105mm lens on your traditional SLR.

There is no magic formula you can always apply to translate digital focal lengths to traditional 35mm numbers, though, because the relationship is determined by the size of the camera's sensor. Camera manufacturers will usually tell you what the 35mm equivalent is. Sometimes, as with digital bodies that accept 35mm lenses, they will tell you the size of the sensor and its relationship to your existing lenses. The Canon 20D, for example, has a sensor that's smaller than 35mm film. The

result is a focal length factor of 1.6×, so your standard 50mm lens becomes an 80mm telephoto when attached to the 20D.

A general rule of thumb is that there's a 50% increase from film to digital: a 14mm nominal focal length lens is around 21mm on a digital SLR. The exceptions are high-end models such as the Canon EOS 1Ds, which have a "full size" sensor (meaning that the lens focal lengths remain the same as in 35mm photography).

The second series of numbers usually looks something like this:

1:2.8–4.0 or *1:2.0–2.5*

These numbers represent the *maximum aperture* of the lens at the wide angle and telephoto settings. Aperture determines the amount of light that can pass through the lens to the camera sensor. Wide apertures, such as 1.8 or 2.0, allow a lot of light to pass through the lens and are therefore better in low-light conditions. Narrower apertures, such as 5.6 or 8, allow less light through the lens and are less desirable for low-light shooting.

When thinking about the best compact or advanced amateur camera for you, keep in mind that you'll have to live with the aperture and zooming range of the lens for the life of the camera. Unlike DSLRs, where you can change the lens, compact cameras have the lens permanently mounted to the body.

Some cameras do provide accessory lenses that mount on the end of the existing glass. These work relatively well, but they are cumbersome and not many options are available.

For advanced amateur models, I recommend a zooming range of at least 5×; more is better. Also pay attention to the wide end of the range. Get a lens that gives you the 35mm equivalent of 28mm on the wide end. Digital cameras are notorious

for not providing you with as much wide-angle coverage as film cameras.

Advanced amateur cameras provide amazing capabilities in a portable package, and often for less than comparable DSLR kits. If you can live with a lens fixed to the camera body, and are willing to sacrifice a bit of high-speed performance, cameras in this class should satisfy the needs of the most critical of photographers.

Professional Cameras

Digital SLRs, like the one shown in Figure 1-7, provide tremendous flexibility for photographers who need to tackle a wide variety of photo assignments. The key feature is the removable lens. Major camera manufacturers such as Nikon and Canon provide you with dozens of lens choices for your DSLR.

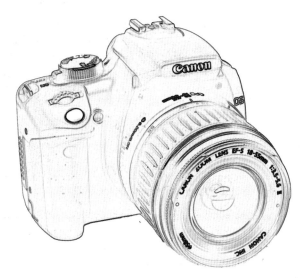

Figure 1-7. Digital SLR with interchangeable picture-taking lens

Sports and nature photographers may lean toward powerful zooms that bring the action in close. Special event shooters will want a high-quality wide-angle lens for working in tight quarters. Portrait photographers need moderate telephotos with wide apertures so they can soften the background. Regardless of how you want to use your DSLR, there's a perfect lens for you.

In this section I'll focus on a few of the key features that distinguish these types of professional cameras from compact and advanced amateur models.

Electronic flashes

Most compact camera shooters, and even many advanced amateurs, live and die by the flashes that are built into their cameras. As you get more serious about your photography, you should consider using at least one external flash unit.

The most basic application is mounting a single flash in the hotshoe of your DSLR or advanced amateur camera. This alone will improve your shots, because you'll have moved the light source (the flash) farther away from the picture-taking lens. By doing so, you'll reduce the effect of red eye and move unsightly shadows lower behind the subject.

You also have the option of using a dedicated flash cord to extend the distance between flash and camera lens. Wedding photographers often use a bracket to position the flash exactly where they want it. The effects of red eye are completely eliminated when using this type of rig.

Wireless flash control is a great alternative, especially when you want to use two or more flash units to light a composition. Typically, you mount a wireless controller in the hotshoe of the camera, then position your flashes on light stands. When you trip the camera shutter, the wireless controller sends out a signal telling the flash units when to fire and for

how long. This amazing system enables you to create sophisticated lighting setups without cumbersome wiring.

Many DSLRs include a pop-up flash on the camera body. This function may come in handy in a pinch, but external flash units are an option worth considering if you're serious about this type of photography.

Image sensors

Instead of film, digital cameras record light with solid-state devices called *image sensors*. I'm going to spend a little time explaining some of the differences commonly found in these components. If this type of discussion gives you a techno-headache, you can read through my image sensor rules of thumb in the next paragraph and skip the rest of the discussion.

Bigger image sensors (in physical dimensions) generally produce better image quality. That's one of the reasons why digital SLRs outperform compacts—they have more real estate to record pixel information. Speaking of pixels, the more megapixels your image sensor supports, the higher the resolution of the photo will be, and therefore the bigger the print it can produce. So, as a rule, 3-megapixel cameras are great for snapshots, but you really need a 5-megapixel or greater sensor for enlargements. That said, keep in mind that the image sensor is only part of the quality equation. The camera's optics and electronics play major roles too.

If you want to know more about why these rules apply, here's a short course in image sensor technology.

The most common sensors are *charge-coupled devices* (CCDs). However, many cameras, such as the Canon SLRs, are now employing *complementary metal oxide semiconductor* (CMOS) sensors, which share many of the same attributes of

CCD types but use less energy. Another type of sensor, called the *Foveon X3*, is the current choice for Sigma SLRs. The Foveon sensor has a much different design compared to its CCD and CMOS brethren. It actually uses three separate layers of pixel sensors embedded in silicon, whereas CCD and CMOS sensors have a single layer.

Image sensors also vary in their dimensions. Many entry-level digital SLRs use sensors that are referred to as *APS* in size. The term APS comes from the alternate 24mm film format (Advanced Photo System) that was introduced in the 1990s but never really gained traction. The label survives because many of today's digital SLRs have image sensors approximately the same size as an APS film frame (roughly 15mm × 23mm). Because the proportions of these APS sensors are smaller than those of 35mm film (24mm × 36mm), cameras containing them have increased image magnification when traditional 35mm lenses are mounted on the body. Typically, this increase is around 1.6×.

Some digital SLRs employ a *four-thirds* image sensor. The major proponent of this system is Olympus. The term four-thirds refers to the proportions of the image sensor, producing images that are 4:3 in dimension. Current four-thirds sensors by Olympus are approximately 13mm × 17mm—smaller than APS-sized sensors, but larger than those found in most point-and-shoots. At the other extreme are the pro-level full-frame SLRs with 24mm × 36mm sensors (the same dimensions as 35mm film).

Instead of physical size, however, most people refer to image sensors by how many *pixels* (picture elements) they support. The term *megapixel* means just that: a million pixels. So instead of saying, "I just bought a camera with a sensor that supports 5,000,000 pixels," you can say, "I just bought a 5-megapixel camera."

Consumer cameras currently range in capacity from 2 to 8 megapixels. Pro cameras have sensors as large as 14 megapixels. Generally speaking, you want at least 3 megapixels for snap-shooting and vacation pictures. The more megapixels your camera has, the bigger the prints you can make. Three-megapixel cameras, for example, can produce quality prints at up to 8" × 10".

Advanced amateurs and pros need more pixel-power than vacation shooters. Having a 6-, 8-, or 12-megapixel image provides you with more options when you process the image on the computer and print it out. You can, for example, push the pixels closer together (increasing the "pixels per inch" setting) to create very smooth tones in the photograph, rivaling the images produced by high-quality film cameras.

More pixels also enable you to crop the original photo, maybe choosing just the center portion of the picture, and still have enough image information to make a high-quality enlargement.

A hefty-megapixel image sensor, however, doesn't ensure amazing photo quality. Other aspects of the camera's optics and electronics play important roles too. For example, a 6-megapixel sensor in a compact camera will be in the neighborhood of 7mm × 9mm in physical size, but a 6-megapixel sensor in a digital SLR will be 15mm × 23mm or larger. That means that each of the *photosites* (photosensitive diodes that collect one pixel's worth of light) on the DSLR's sensor is physically bigger. These bigger photosites collect more light and result in better image quality and reduced digital noise.

In the end, the best way to think about image sensors is the same way you think about the engine in your car: yes, it's vital to the car's performance, but there are many other factors that contribute to a good ride. And don't forget, the driver has something to do with it too.

Optics

Since you have so many lenses to choose from with a DSLR, where do you start? Regardless of your specialty, all photographers need one or two "bread and butter" optics for everyday use.

The most essential lens is the moderate wide-angle to telephoto zoom. The Nikon VR 24mm to 120mm and the Canon IS 17mm to 85mm zooms are good examples. They both range from substantial wide angle to moderate telephoto with 5× magnification. Both incorporate image stabilization technologies to reduce the effect of camera shake in low-light conditions. And with either, you can go out for a day of shooting with just that lens and be ready for most situations you'll encounter.

When shopping for a lens for your DSLR, keep in mind that you might have to factor image magnification into the equation (see the earlier discussion of zoom lenses under "Advanced Amateur Cameras" for more information). The Canon 20D, for example, has a 1.6× image magnification, which means that a 17–85mm zoom lens will become a 27–136mm lens when mounted on the 20D.

Finally, always keep portability in mind when lens shopping. You can spend hundreds or even thousands of dollars on a wide-aperture lens with an impressive zooming range, but if it's too heavy to cart around, or won't fit in your camera bag, you've defeated your primary purpose: to buy a lens that you like to shoot with and will have with you when you need it.

WiFi image transfer

Nikon made a splash at the 2004 PMA show with its WT-1 WiFi adapter for the Nikon D2H DSLR. This adapter enabled photographers to "send" their images via 802.11 wireless networks, eliminating the need to physically connect the camera, or the memory card, to a computer.

WiFi technology has been around for some time and is typically used to enable Internet connectivity in coffee shops, airports, and businesses that have "hotspot" capability. Soon, sending pictures from your camera might be as easy as sending email from your computer. Kodak has already announced a consumer camera with this technology built in, and more are sure to follow.

Hybrid Devices

There are three exciting areas where digital imaging is converging with other functionality: phones with cameras built into them, digital camcorders with still picture capability, and still cameras that can record high-quality video.

Cameraphones

The most notable of the hybrid devices is the cameraphone, like the one shown in Figure 1-8. Manufacturers of these devices have already figured out how to add megapixel resolution, digital zoom lenses, and even electronic flashes to the devices that you've been using to make phone calls. Mobile phones have yet to evolve to the point where they can replace your compact camera, but they are becoming a more tempting alternative for the "camera you always have with you."

One of the downsides to cameraphones compared to dedicated compact cameras is the learning curve for managing your pictures once you've captured them. Typically, you don't simply connect the phone to your PC via a USB cable and let your computer take it from there (although some models do enable this). Here is an overview of the transfer options most often available with cameraphones:

Removable memory card Devices such as the PalmOne Treo 650 enable you to write your pictures to a Secure Digital memory card, remove the card from the device, and then transfer the pictures via a card reader connected to your computer.

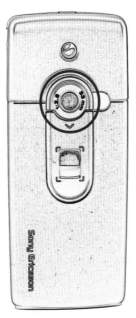

Figure 1-8. The picture-taking lens on a cameraphone

Bluetooth wireless Some cameraphones have built-in Bluetooth wireless connectivity that allows you to "send" your pictures to another Bluetooth-enabled device. This could be your computer, another cameraphone, a PDA, or even a Bluetooth printer.

Infrared (IR) transfer IR image transfer works similarly to Bluetooth, but it isn't as fast. Again, both devices have to have an IR transceiver to move the pictures.

Email Many cameraphones enable you to send and receive email. You can attach a picture to an email and send it to your computer.

Multimedia Messaging Service (MMS) MMS is an extension of the text-only Short Messaging Service (SMS) that allows

you to send pictures, audio, and even video from your cameraphone. Typically you'd send these messages to another MMS-enabled phone or to an online service such as Textamerica, where others can log on to see your work.

True, there is a certain "geek factor" that comes with managing cameraphone images. But there's no denying the portability of these devices, and handling the pictures they produce will only get easier with widespread adoption.

DV Camcorders That Capture Stills

The second area of convergence features digital camcorders that can capture megapixel still pictures. Many consumer models offer 2-megapixel or higher image sensors. The images are stored on a memory card (see Figure 1-9), not on the DV tape cassette.

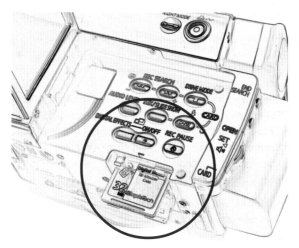

Figure 1-9. The memory card slot on a digital camcorder that has megapixel still picture capability

You can transfer the pictures to your PC via a supplied USB cable, similar to the one that comes with your digital camera. You can also remove the memory card and insert it into a card reader connected to your PC.

One of the coolest features of these hybrid camcorders is their ability to print your pictures via a direct connection to your home printer. (Of course, both the camcorder and the printer will need to have either PictBridge or Direct Print technology for this function to work.) If you want to capture your vacation snapshots and travel movies with the same device, this tandem is something to consider.

If you're serious about shooting photos with your camcorder, look for a model that includes an electronic flash, accepts an external flash unit in its accessory shoe, and has a menu of useful still-photography functions, such as exposure compensation, white balance, panorama, and flash control options.

Many of the techniques explained in this guide work perfectly well with megapixel-equipped DV camcorders.

Still Cameras That Record High-Quality Movies

Another promising evolution in digital imaging features MPEG-4 movie capture abilities built right into digital still cameras. MPEG-4 provides high-quality video and audio in a very compressed format. Many of these hybrid still cameras can record 30–60 minutes of top-quality video to a 1-GB memory card.

Cameras with this capability often borrow many of our favorite features from DV camcorders, the most notable being a rotating LCD monitor (like the one shown in Figure 1-10). This allows you to capture video from just about any angle, high or low. Another feature that's more often included is stereo audio recording via two microphones positioned on the body of the camera.

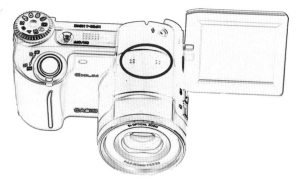

Figure 1-10. A hybrid digital still camera with stereo microphones (circled) that captures MPEG-4 video

Of course, you don't have the overall control for movie capture with these digicams that you'd enjoy with DV camcorders. They seldom have inputs for external microphones or accessory shoes for video lights. But if you like to make the occasional movie and don't want to carry two devices, this new breed of digital still camera is worth a look. You can learn more about how to capture interesting movies in the Chapter 2 section titled "Movie Mode," and in Chapter 3 I'll explain how to edit those videos on your computer so you can transform them from random snippets to compelling presentations.

Putting It All Together

Now that you're familiar with the features of your digital camera, how do you use them to take great pictures? In the next chapter, *What Does It Do?*, you'll learn helpful techniques such as how to master the focus lock, how to choose the right flash setting, and how to use "burst mode" to capture action shots—plus lots more. Great pictures are only a chapter away.

What Does It Do?
Taking Control of Buttons, Dials, and Menus

Now that you're familiar with your camera's basic components, you can concentrate on how to unlock its picture-taking magic. For example, you probably understand that a simple flash menu button (⚡) allows you to cycle through a series of versatile lighting controls. But what do they mean, and which one should you choose?

In this chapter, you'll learn how to use those deceptively simple buttons and dials to tap into the incredible picture-taking capacity hidden within your digital camera.

Digital Camera Controls A–Z

This chapter covers camera controls alphabetically from A to Z, or more specifically, from Aperture Value Mode to Zooming. New terms are listed in *italic*. If you're not sure where to find any of these settings on your particular camera, double-check the owner's manual, or refer to Chapter 1 of this guide.

NOTE

> As always, it's best to have your camera in hand as you work with the text and study the photo examples. The more you shoot, the more natural these techniques will become.

Aperture Value (Av) Mode

Many intermediate and advanced cameras allow you to choose the aperture setting, and the camera sets the proper corresponding shutter speed. This setting is sometimes denoted as *Av*, which stands for *aperture value*. (Some cameras just go with a simple "A" for aperture priority.) You can typically access this setting via the mode dial or as a menu option.

Choose the aperture priority mode when you want to control *depth of field*. In other words, how much of your picture, from front to back, do you want in focus? Shallow depth of field is often used for portraits—your subject is in focus, but everything else is a little soft. Choose an aperture value of 2.0, 2.8, or 4 for this type of shooting situation. The lower the value, the shallower the depth of field will be, and less of the image will be in focus (see Table 2-1 for specific depth of field settings).

Table 2-1. Depth of field settings

f-stop	Diameter of aperture	Depth of field	Background looks
f-2	Very large diameter	Very shallow	Very soft
f-2.8	Large diameter	Shallow	Soft
f-4	Medium diameter	Moderate	A little out of focus
f-5.6	Medium diameter	Moderate	A little out of focus
f-8	Small diameter	Moderately deep	Mostly in focus
f-11	Small diameter	Deep	Sharp
f-16	Very small diameter	Very deep	Very sharp

When shooting landscapes, you'll probably want "deep" depth of field, which produces a sharp image from foreground to background. Choose an aperture value of 8, 11, or 16 for deeper depth of field.

Shooting an Outdoor Portrait
with a Soft Background

If your camera has a portrait-shooting mode, it's designed to "open up" the aperture to provide a shallow depth of field. Or, you can use aperture priority and select f-2, f-2.5, or f-2.8. Place the subject at least 10 feet away from the background, more if possible. This will soften the background detail, putting more emphasis on your subject. Set your zoom lens to the telephoto position (this enhances the soft background effect even more). Focus on the model's eyes. Press the shutter halfway to "lock" the focus. While still holding the shutter in the halfway position, recompose so the composition is just the way you want it. Then take the picture. If the lighting on the model's face isn't to your liking, force the flash on (see the "Flash Modes" entry later in this chapter), and shoot again. This setup should provide a nicely focused model against a softened background (see the example in Figure 2-1).

Figure 2-1. Soft background portrait captured with Canon 10D and 85mm, f-1.8 lens set to f-2

Autoexposure

See "Programmed Autoexposure."

AVI

Short for *Audio Video Interleaved*, *.avi* files are one of the most common formats for storing audio and video captured with a digital camera. Even though AVI is considered a Microsoft Windows format, most variants of it play on Macintosh computers as well. If your digital camera records video, chances are good that you'll see this file designation on your memory card. Other common video formats used on digital cameras include *.mov* (QuickTime movie) and *.mpeg* (Motion Picture Experts Group). Many new cameras use MPEG-4 compression for their movies. See the "MPEG-4 Movie Format" entry later in this chapter for more information.

Burst/Continuous Shooting Mode

All but the most basic cameras have some sort of *burst* or *continuous shooting* mode. The icon, shown in Figure 2-2, looks like layers of rectangles. Typically this mode is a menu option, but some cameras display it as a button option that you can access at any time. Either way, it allows you to shoot a series of pictures while holding the shutter button in the down position. The number of pictures you can record in one burst is determined by the capacity of your camera's *RAM buffer* (discussed in Chapter 1).

Most people use this continuous shooting feature for recording sports events, and it is a great choice for capturing a baseball player's swing or a quarterback's touchdown pass. But burst mode can also help you compensate for *shutter lag*— that diabolical delay from the moment you press the shutter to when the picture is actually recorded. Some digital cameras

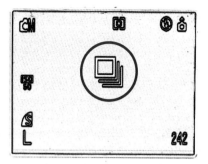

Figure 2-2. Burst/continuous shooting mode menu icon

have shutter lags as long as one second, which is a lifetime in action photography.

The key to overcoming shutter lag by using burst mode is to start the sequence just before the action begins, then shoot continuously until the buffer fills up. By doing so, you greatly increase your chances of capturing the decisive moment.

PRACTICAL EXAMPLE

Capturing the Decisive Moment

To catch a precise moment of an activity or event, set your camera to *continuous* or *burst* mode. First, make sure the activity is taking place in a well-lit room or, even better, outdoors (and turn off your flash—flashes can't fire fast enough to keep pace with burst mode photography). Focus on the subject and hold the shutter down halfway to lock it in. Still holding the shutter in the halfway position, recompose. Start the series as the subject approaches the decisive moment (nearing the finish line, blowing out birthday candles, etc.), and shoot continuously until the RAM buffer fills up and the camera stops taking pictures.

continued

Capturing the Decisive Moment

You'll have to wait a moment for the camera to process all the information you've just recorded. Then go back through the sequence you shot and choose the picture that best depicts the decisive moment.

For instance, in Figure 2-3, I've chosen the moment when the cyclists have just rounded the corner and are in an interesting formation. You can either erase the others to save memory card space, or keep them to show the entire sequence.

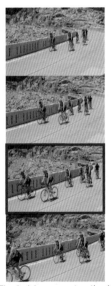

Figure 2-3. The decisive moment as the riders make the turn

Close-ups

Digital cameras are great for getting in real tight with your subject. This is sometimes referred to as *macro photography*. Unlike most film cameras, digicams usually have the macro capability built right into the camera—you don't need any special accessories for impressive close-ups. Usually, you can access the macro mode by pressing the button that has the "flower" icon next to it (❁). Some cameras may bury this option in the onscreen menus and force you to dig a little bit to find it. But keep looking; it's in there somewhere.

The main thing to remember with close-up photography is that whenever you increase lens magnification, you have to hold the camera extra steady, as too much camera movement during the exposure can make your picture look out of focus. For important close-ups that you plan on printing, you may even want to use a tripod to steady the camera. The rule of thumb is this: *increased magnification means increased camera shake.*

Also, your depth of field is very shallow in close-up photography, so be sure to focus on the element that is most important to you. If you have an aperture priority mode, you can increase the depth of field a little by setting the aperture to f-11, f-16, or f-22. The higher the f-stop setting, the more depth of field you'll have.

PRACTICAL EXAMPLE

Taking a Close-up of a Flower

Put your camera on a tripod. Turn on the close-up mode, and turn off your flash (many digital camera flashes overexpose subjects at very close range). Focus your camera on the most important element in the composition, and hold the shutter halfway down to lock in the focus.

continued

Taking a Close-up of a Flower

While still holding the shutter in the halfway position, recompose if you need to, then shoot the picture. If there's a breeze blowing, wait for a calm moment before shooting: your picture will be sharper. Review your work after a few shots, then make any necessary adjustments. If you have a manual focus option on your camera, you can compose your picture first, then manually focus. Use the self-timer or the remote release to trip the shutter—that will prevent you from jarring the camera when you take the shot.

Take a look at the close-up shot of a purple and white Lupine flower in **Figure 2-4**. The focus is set on the flower petals. Notice that because of the shallow depth of field, the background foliage falls out of focus quickly. This is due to the increased magnification of close-up photography.

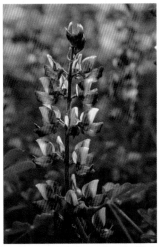

Figure 2-4. Close-up shot of a purple and white Lupine flower

Composition

Whether you're using the LCD monitor or the optical viewfinder, the composition of your picture determines a large part of its success. *Composition* is the arrangement of the elements in your photograph. The subject, the horizon line, and background elements all play a role in successful composition, and this is just as true with basic point-and-shoot cameras as it is with a top-of-the-line Nikon digital SLR.

The first step to creating great photographs is to consider all the elements in your viewfinder. Here are a few questions to consider when framing your picture: Where is the subject placed? Are there any distracting background elements, such as telephone poles? Is the horizon line straight? Should you raise the camera angle, or lower it?

Most photographers keep five rules of thumb in mind when composing their shots. These are not hard and fast rules, but they are worth remembering and applying as often as possible.

Get closer. Use your feet and your zoom lens to frame your subject as tightly as possible. Once you get closer and compose your image, take a few shots, then get closer again. Your pictures will improve dramatically.

Remember the Rule of Thirds. Don't always put your subject dead center in the frame. Instead, divide the frame into thirds, both horizontally and vertically (like a tic-tactoe board), and position the important elements along those lines. Your compositions will be less static and more interesting.

Eliminate busy backgrounds. Trees are great, but not when they're growing out of the tops of people's heads. Look out for busy patterns, bright objects, and other distracting elements.

Go high, go low. Change your camera angle when working a shot. Get low on the ground and shoot upward. Raise the camera over your head and shoot down—swiveling lenses and LCD monitors make this easier than ever.

Simple is better. Try not to clutter your compositions with nonessential elements. Keep things simple, move in close, and find an interesting arrangement.

PRACTICAL EXAMPLE

Analyzing a Landscape Composition

When you first look at Figure 2-5, you'll most likely find the image pleasing. But why? There are a number of compositional rules in effect here that contribute to the success of this photograph. Notice the first place your eye goes to in the image—the gun tower. By placing it in the left third of the composition with a diagonal line leading to it (the fence), you can actually direct the viewer's eye to where you want it to go first. The solid background of trees doesn't distract from the fort, yet provides some nice color and texture for the shot. Two large Eucalyptus trees on either side of the fort serve as a frame to help direct the eye inward. Also notice that the foreground, which is composed to also help pull the viewer's eye inward, is slightly soft. If you prefer a sharper foreground, simply increase your depth of field by choosing an aperture of f-16 or so, and focus on the bend in the fence.

continued

Analyzing a Landscape Composition

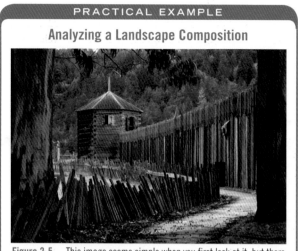

Figure 2-5. This image seems simple when you first look at it, but there are many compositional rules in effect that contribute to its success

Compression and Image Quality

Another way in which digital cameras differ from their film counterparts is that they actually let you set the quality of the image via the *compression* or *image quality* setting. All digital cameras save images as some form of Joint Photographic Experts Group (JPEG) file. If you've worked with JPEGs, you know that you can save them at various quality levels, usually from 1 to 12. A JPEG saved at level 1 has both very poor quality and a very small file size—it is said to be *highly compressed*. The same file saved at level 12 has excellent image quality, but the corresponding file size is quite large—it is *minimally compressed*.

Your digital camera gives you some of these same options in the compression or image quality setting, shown in Figure 2-6, which is usually one of the first items you'll see when you open the onscreen menu. Instead of providing you with number values such as "3," "6," and "9," cameras use terms such as *basic*, *normal*, and *fine*, or *normal*, *fine*, and *superfine*. Regardless of the actual terms used, pay attention to the order in which they are listed.

- *Basic* or *normal* is high compression and should be avoided, because it limits your ability to make good prints. Don't be tempted by the number of extra pictures you can squeeze onto a card using high compression—it is much better to buy a bigger memory card instead.

- *Normal* or *fine* is medium compression and is acceptable for images you are going to email or post on the Web. You can also make decent prints from images at this setting.

- *Fine* or *superfine* is the lowest compression setting on your camera and the one you should consider using all the time. True, you won't be able to squeeze as many pictures onto your memory card as you would using the higher compression settings, but you're capturing images at their highest quality and will always have the option of producing quality prints or large web images from all of your shots.

Some cameras also provide *RAW* or *TIFF* format options. These settings don't use any compression and produce very large files. If you know that the final product is going to be a large print or a picture in a magazine, then these settings are worth considering. But for everyday shooting, they might be overkill. For more information, see "Work with RAW Files" in Chapter 3.

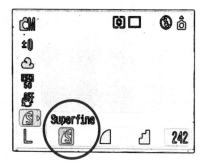

Figure 2-6. Compression levels: in this menu the "S" stands for "superfine," which is this camera's highest quality setting

For general shooting, you should be happy with the quality of pictures set at the highest compression level, which is usually *fine* or *superfine*.

Continuous Shooting Mode

See "Burst/Continuous Shooting Mode."

Deleting Images

See "Erasing Images."

Digital Zoom

Unlike the *optical zoom* on your camera, which consists of actual glass elements, the *digital zoom* is a function of the camera's electronics. By enabling the digital zoom, you can increase the magnification of your lens to bring your subjects even closer than is possible with just the optics alone.

The trade-off is that you compromise image quality when you use the digital zoom. Since it's a function of the camera's electronics and not of the actual lens, the digital zoom is really emulating the telephoto effect instead of actually recording the

image at that optical magnification—so even though you "get closer" by using the digital zoom, there's some quality loss too.

You're usually better off staying within the limits of your optics, then cropping the picture later on your computer. You achieve the same effect of moving in closer, but without the image loss.

> **REMINDER**
>
> Don't base a camera-buying decision on the digital zoom rating. Consider only the optical zoom numbers.

DNG

Digital Negative Specification. See "File Formats (Still Images)."

Erasing Images

There are two types of erasing. Most photographers use the *single erase* option when they take a bad picture and want to get rid of it to free up space on the memory card. Cameras usually have a "trash" button for this procedure (see **Figure 2-7**). The other type of erasing is to use the *Erase All* command to wipe every picture off your card, usually after you've just uploaded them to your computer. The Erase All command is usually a menu item. You can also use the *Format Card* command, but before using either method to wipe clean the memory card, double-check that you have indeed uploaded your pictures to your computer.

As for single erase, sometimes photographers discard images too quickly, before fully examining them. Obviously some pictures need to go right away—if you're in a dark room and the flash

Figure 2-7. Pressing the trash button deletes the image displayed on the LCD monitor

doesn't fire, it's a pretty safe bet to dump that shot. But if you take a series of images and want to erase all but the best, make sure you carefully examine the others. Many digital cameras provide a magnify function for the LCD monitor. Try zooming in on your potential discards, and examine them closely before pressing the trash button. To be extra safe, view them on the computer, then trash them if they still don't make the cut. You can miss subtle details when viewing pictures on the tiny LCD monitor, and sometimes those very details make a great shot.

REMINDER

Never use your computer to erase a memory card. Instead, use the Erase All command on your camera. This will ensure the best communication between the memory card and your camera.

So, once you know for sure that you want to remove all the images you have stored on your memory card, which command is better to use: Erase All or Format Card? Generally speaking, you should use Erase All. Doing so gives you better odds of recovering accidentally erased images with software such as Lexar's Image Rescue (*http://www.lexar.com/software/ image_rescue.html*). Memory cards that have been reformatted are more difficult, if not impossible, to salvage images from. However, if you use burst mode often or record digital movies, it's a good idea to use the Format Card command on occasion, to "clean up" the card's memory and ensure top-notch performance.

Exposure Compensation

One of the most valuable tools available on your digital camera is the *exposure compensation* scale, which allows you to override your camera's autoexposure reading so you can capture the image exactly the way you want it. On some cameras, this is a button option that you can get to easily, and on others it's a menu item that's not quite as convenient. Either way, you'll want to know where exposure compensation is on your camera—it can help you take pictures that more accurately represent the scene you're trying to capture and save you time later when adjusting the exposure on your computer.

You may be thinking, "But doesn't my camera always know the right exposure to set?" Not entirely. The light meter in your camera is calibrated to expose properly for anything that's 18% gray. This represents the approximate light reflection of a deep blue sky or green foliage, which are the most common backgrounds in outdoor shots. And indeed, your light meter works great most of the time.

But what if you want to shoot a white statue of St. Francis? It's not 18% gray; it's white! If you don't override your camera's light meter via exposure compensation, your camera will render that statue in 18% gray. In effect, your automatic wonder digicam will *underexpose* your subject.

You can use your camera's exposure compensation option to render the image correctly. When you find the control, you'll see a scale with "0" in the middle, positive numbers to the right, and negative numbers to the left, as shown in Figure 2-8.

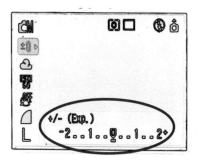

Figure 2-8. The exposure compensation scale

When you're shooting an object that's very bright, such as a white statue, you may want to *add* more exposure to render it white. So, move the pointer on the exposure scale to +1.

On the other hand, if you're shooting a very dark object with your camera in autoexposure mode, the camera will overexpose the shot and render the object lighter than it really is. If you want to avoid this situation, you should subtract exposure by moving the pointer on the exposure scale to −1.

As you become more comfortable with the exposure compensation function, you can make more subtle adjustments to

your pictures. You can also fine-tune your images later in Photoshop or another image editor, but the more energy you put into capturing your pictures the way you want them in the first place, the less time you'll have to spend processing them later.

Choosing Exposure Compensation Settings

In Figure 2-9, you see how most cameras would record this image—the white statue is rendered grayish. In Figure 2-10, +2/3 exposure compensation has been added, making St. Francis look a little brighter. Figure 2-11 adds a full stop of compensation. Which figure is the right one? That depends on your eye.

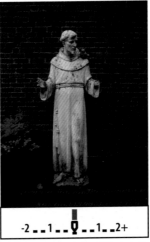

-2 _ _ 1 _ _ 0 _ _ 1 _ _ 2+

Figure 2-9. White statue is a little dark when shot without exposure compensation

continued

Choosing Exposure Compensation Settings

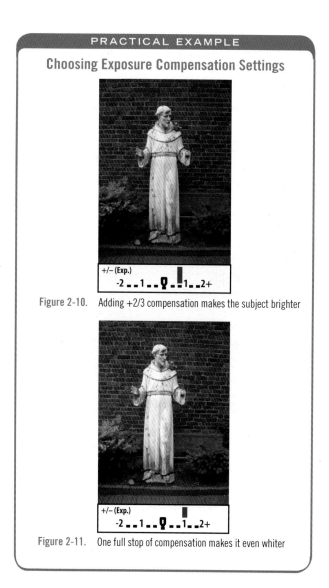

Figure 2-10. Adding +2/3 compensation makes the subject brighter

Figure 2-11. One full stop of compensation makes it even whiter

Exposure Lock

Typically, when you press the shutter button halfway down and hold it there, the camera locks in both the *focus* and the *exposure*. While still holding the button halfway down, you can then recompose the shot and take the picture. But what if you want to lock the focus on one item and the exposure on another element?

Some cameras allow you to lock the exposure independently of the focus. If your camera has this function (you can see the icon in Figure 2-12), it usually works like this: first, you press the shutter button halfway to take a meter reading; while still holding down the shutter button, you then press another button to lock in the exposure. An indicator usually appears on the LCD screen to let you know you've locked the exposure. Now you can focus on another element and take the picture. Remember to turn off the exposure lock once you're done working with that particular shot.

For example, say you want to take a picture of your daughter wearing a white outfit and standing in the sunshine on a bright day. You want the camera to focus on her, but you know that because she's wearing white in the full sun, your digicam will have a hard time getting the exposure right. The green grass is much closer to the magical 18% gray that exposure meters are calibrated for.

The solution is to lock the focus on your daughter, then point the camera at the grass and press the exposure lock button. You've just instructed the camera to focus on one part of the scene and measure the exposure from another part. The result? A beautiful portrait of your daughter.

You can use exposure lock as a shortcut for exposure compensation. Instead of accessing the exposure scale and adjusting your image that way, you can find a middle tone in the picture you want to shoot, such as a patch of grass, and lock your

Figure 2-12. The icon for the exposure lock button

exposure on it. This is a faster way to override your camera's autoexposure setting in difficult lighting situations.

Exposure Metering

Most digital cameras rely on *programmed autoexposure metering* to set the aperture and shutter speed. Essentially, the camera's light meter "reads" the light and compares the data to a set of instructions stored in the camera's memory. The camera then chooses the best aperture/shutter speed combination based on the data it receives from the light meter.

The most important thing you need to know about exposure metering is that cameras are not perfect when it comes to evaluating exposure. They are most often fooled by very bright or very dark subjects.

Fortunately, most cameras allow you to override the pro-grammed exposure setting (see the "Exposure Compensa-tion" entry).

File Formats (Still Images)

JPEG is the format used by most digital cameras. JPEG files are very portable and can be read by nearly every computer and web browser. JPEG files use compression to keep the file size small for easy transport. You can determine the amount of compression by selecting options from the menu function on your digital camera—usually "high," "medium," and "low," but not always using those exact terms. For example, the terms "superfine," "fine," and "normal" are sometimes used instead. See the "Compression and Image Quality" entry for more detail about these settings.

Over the last few years, a specialized version of JPEG has emerged for digital camera use. Exchangeable Image File (EXIF) has the same compression properties as the standard JPEG file format, but allows the camera to record to the pic-ture file additional data—such as shutter speed, aperture, and date—that can be "read" by most modern image editors. This additional information is sometimes referred to as *metadata*, and it's a real blessing for photographers who like to be able to access the technical specifications for every shot they record, but hate taking notes. The current EXIF version is 2.2.

Tagged Image File Format (TIFF) settings are sometimes available as an alternate high-quality format. TIFFs recorded by digital cameras are usually not compressed, though, so file sizes are very large. For general shooting, using the "high" quality JPEG setting is just fine. But for those special situa-tions when you want to squeeze every drop of quality from the image, the TIFF setting might be appropriate.

Some camera makers also provide a RAW format option that is also uncompressed. As with TIFFs, the file sizes are large,

and the quality is very high. RAW is a good choice for the most accurate color fidelity because you can delay your white balance choice until later, while you're working on the computer. But keep in mind that the time your camera takes to write information to the memory card might be longer when using this format, and you might need a special application to work with these images on your computer. For more information, see "Work with RAW Files" in Chapter 3.

Adobe's Digital Negative Specification (DNG) is an archival format for digital camera RAW data. This format can be used in a couple of ways. You can convert your existing RAW files to DNG using a free converter available from Adobe. The DNG file sizes are more compressed (without quality loss), and you'll then have a standard working format for the various RAW formats you use.

Some manufacturers, such as Leica and Hasselblad, have adopted DNG as the high-quality format inside the camera, too. At this point it's difficult to say how widespread the DNG format will become, but it's certainly worth keeping an eye on.

The relative sizes of these common file formats, based on a 6-megapixel picture, are shown in Figure 2-13. The CRW file is the Canon version of a RAW image. Note how much smaller the file size is for a JPEG than for a RAW file.

Name	Size ▼	Kind
Photo_1660.tif	18 MB	Adobe Photoshop TIFF file
Photo_1660.crw	6.2 MB	File Viewer Utility Document
Photo_1660.dng	4.8 MB	Digital Negative
Photo_1660.jpg	476 KB	Adobe Photoshop JPEG file

Figure 2-13. Relative sizes of common file formats

Film Speed

See "ISO Speed."

Flash Compensation

This feature, more common on advanced amateur cameras than on basic point-and-shoots, enables you to manually adjust the flash exposure. Much in the same way that exposure compensation gives you a tool for fine-tuning your camera's programmed autoexposure, flash compensation provides a way to increase or decrease light output from your flash. So if your subject is too bright after you take a test shot (i.e., the image is overexposed), you can set flash compensation to −1 to decrease the light output. On the other hand, if your model is rendered too dark in the first shot, you can set flash compensation to +1 to increase the light output.

Flash Modes

The default flash mode for most cameras is automatic, and that's where it stays for most folks. But even the most basic of digicams offers multiple flash settings that can help you take engaging photos under a variety of lighting conditions. Some of the typical flash settings that you might encounter on your camera are:

Auto The camera activates the flash as determined by the light meter reading. If you're indoors in low light, the flash fires. Outside on a bright sunny day? The camera turns off the flash.

Red eye reduction Many digicams have some sort of red eye reduction mode. Red eye occurs when the subject's eyes are dilated (in dim lighting), exposing the retina. When the light from the flash reflects off the retina, the resulting color is red. Most cameras tackle this problem by shining a light at the subject before the flash goes off. The pre-flash causes the pupils to constrict, which may reduce the chance of red eye.

The challenge for a photographer using red eye reduction flash modes is coping with the extended delay from the time the shutter button is pressed until the actual picture is recorded. If you use red eye reduction, remind the subject to hold the pose until the final flash has fired, and remember to hold the camera steady during this entire process.

Auto red eye reduction The combination of auto and red eye reduction modes. The camera uses red eye reduction whenever it determines that flash is required.

Flash on This setting is usually referred to as *fill flash*. The camera will fire the flash with every exposure, regardless of the light meter reading. "Flash on" is one of the most useful camera settings, because it allows you to take professional-looking portraits outdoors by adding enough light to properly illuminate the subject while balancing the exposure for the background. The result is a beautiful image with all components properly exposed (see Figure 2-15).

Flash off Sometimes the flash destroys the mood of a shot. This is particularly true with indoor portraits where the subject is next to a window with daylight streaming in. Creative photographers like to turn off the flash in these settings, steady the camera, and record an *existing light* photograph that captures the mood of the setting.

Slow-synchro flash Often referred to as *nighttime* mode, this setting tells your camera to use a slow shutter speed in combination with the flash. By doing this, you can capture more background detail in dimly lit scenes, such as portraits shot at twilight, or in an indoor shoot where you want to capture the mood of the setting in addition to having your main subject properly exposed by the flash. Remember to hold the camera very steady when using slow-synchro flash, to prevent blurring of the background. If you have a tripod, you may want to use it for these types of shots.

To Flash or Not to Flash

The two most valuable flash modes are flash on and flash off. Yes, auto flash is fine for most situations, but sometimes you have to override auto mode to capture the shot you want. Outdoor portraits, for example, look great when you enable the flash on mode. The camera will automatically balance the background exposure and supply just the right amount of flash to perfectly illuminate your subject. Notice the difference between Figures 2-14 and 2-15. In Figure 2-14, the background lighting is fooling the camera, causing underexposure of the subject. In Figure 2-15, the fill flash helps balance background and subject exposure. Just remember to work within flash range, which is 8–10 feet for most cameras.

Figure 2-14. Background lighting causing underexposure of subject

continued

To Flash or Not to Flash

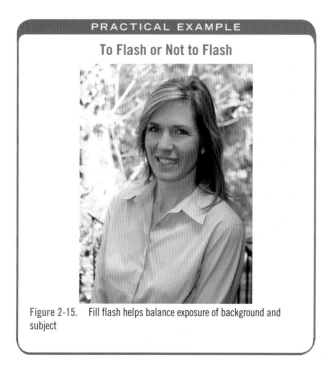

Figure 2-15. Fill flash helps balance exposure of background and subject

Focus Lock

One of the most common pitfalls with point-and-shoot cameras is their tendency to focus on objects other than your intended subject. Instead of capturing your best friend perfectly exposed and in focus, the back wall 10 feet away is sharp as a tack, while your buddy is a fuzzy blob in the foreground. The odds for this scenario increase if your buddy is standing off to one side of the frame.

You can avoid blurring your buddy by using focus lock. Simply point your camera directly at the primary subject, then depress the shutter button halfway until the focus confirmation light goes on. Continue holding the shutter button down

in the halfway position and recompose your shot. Then take the picture.

Format Card

Often included as a menu item, the Format Card command is an alternative to Erase All. Either procedure clears your memory card of all images so you can shoot more pictures, but Format Card also customizes the memory card to your camera by writing a small amount of data to it. This is a good option to choose before you start using a new memory card, or if you're switching in a memory card from another camera. You'll enjoy better performance if you format your memory card using your camera, rather than your computer. Keep in mind, however, that after formatting the card you probably won't be able to recover any accidentally erased images—until you're sure all of your pictures are safe and sound (and backed up!), you might want to use the Erase All command instead of Format Card.

Infinity Lock

Some cameras have an *infinity setting* (▲▲) that allows you to "lock" the focus on subjects that are 10 feet away or farther. At first this might not seem like an overly useful addition to your camera's feature set, but infinity lock is particularly handy in situations when your camera's autofocus system has difficulty "locking in" on a subject, causing it to "hunt" as it searches for the correct setting. In this case, you simply select the infinity lock and shoot away.

Infinity lock helps reduce shutter lag, too. If, for example, you're taking pictures at your daughter's soccer game and are missing too many shots because of the lag between the time you press the shutter button and the moment the picture is

actually recorded, try using the infinity lock. The camera is now pre-focused and will respond more quickly.

Also, if you're shooting landscapes through a car or train window and the camera is having a hard time focusing through the glass, enabling the infinity lock feature should solve your problem.

ISO Speed

Sometimes referred to as "film speed," *ISO speed* is actually a better term for expressing the light sensitivity of your digital camera. ISO stands for International Organization for Standardization. This entity has established many standards, including those for light sensitivity of photographic materials.

If your camera has multiple ISO speed settings, you can use these adjustments to increase the light sensitivity of the image sensor. The default setting for most digicams is *ISO 100* (see Figure 2-16). This is the speed setting for general photography. If you're in a low-light situation and need to increase the sensitivity of your image sensor, change the ISO speed setting from 100 to 200, or even 400, if necessary. Each setting is equivalent to one f-stop of light.

Figure 2-16. Keep your ISO setting at 50, 100, or "Auto" for general shooting in daylight settings

Keep in mind, though, that increasing the ISO speed also increases *image noise*, which decreases the quality of your picture. Image noise is more of a problem with compact consumer cameras than with digital SLRs. Generally speaking, you can push the ISO setting on a DSLR to 400 or even 800 and still get excellent quality. For consumer cameras, however, try to keep the setting at 50 or 100, and save the higher ratings for low-light situations where the importance of getting the shot is worth a little extra noise.

> **REMINDER**
>
> If you do increase the ISO speed for a special situation, be sure to change the setting back to 100 right after the shoot. You will be sorely disappointed if you photograph a beautiful landscape the next day at ISO 1600.

JPEG

Joint Photographic Experts Group. See "File Formats (Still Images)."

Macro Mode

See "Close-ups."

Magnify Control

See "Zoom/Magnify Control."

Manual Exposure Mode

Many compact digital cameras allow only programmed autoexposure, but more advanced models also provide complete control over the aperture and speed settings. If your camera has this option, it's probably denoted as *manual* or *manual exposure mode*.

In traditional film photography, switching to manual mode was a true rite of passage. The photographer would fiddle with the aperture and shutter speed settings, then hope that the pictures were properly exposed when returned from the photo finisher. This process was by no means for the faint of heart. But digital photography has changed all of that, and because you can preview the final result on the LCD monitor before you press the shutter button, manual mode has become much more friendly. Now manual mode represents both control and convenience.

For outdoor photography, start by setting your shutter speed to 1/125th of a second and the aperture to f-8. Preview the scene in your LCD monitor. If the image looks too dark, then "open up" the aperture to f-5.6 or "slow down" the shutter speed to 1/60th of a second. You'll see the results of your adjustments in real time on the LCD monitor. If the scene is too bright, "stop down" the aperture to f-11 or "speed up" the shutter to 1/250th of a second.

This is the beauty of manual mode photography—you have the option of adjusting the aperture and the shutter speed to reach the desired result. Sometimes aperture is more important, such as for portraits where you want to soften the background. In that case, set the aperture to f-2.0 or f-2.8 (wide open), and change the shutter speed until the image looks correct in the LCD monitor.

At other times shutter speed might be more important, such as for "stopping the action" during a sporting event: set the shutter speed to 1/500th of a second and adjust the aperture until the image looks properly exposed.

With a little practice, you'll find that manual exposure is an easy way for you to be in complete control of your digital camera.

Movie Mode

Digital cameras are versatile imaging tools; many provide the option to capture video (often with sound) as well as still images. Typically, you access this function via the *movie mode* setting (see Figure 2-17).

Figure 2-17. Look for movie capture icons on the mode dial or in the menu—this Casio EX-P505 has four movie-capture options

Less expensive cameras sometimes limit your capture to only 30 seconds of video at a time. After it records the sequence, the camera then writes the data to the memory card and allows you to shoot another 30 seconds, and so on until the memory card is full.

But thanks to improved video codecs (short for compressor/decompressor), more robust internal electronics,

advanced battery technology, and cheaper high-capacity memory cards, many advanced consumer cameras enable you to record full-size (640 × 480), full-speed (30 frames per second) video until the memory card is full. The play-back quality still isn't quite as good as the footage you can capture with a dedicated DV camcorder, but it's getting closer to that standard every day. Some digital cameras, often referred to as "hybrid" models, let you shoot for an hour if you have a 1-GB memory card.

You can preview your movies on the camera's LCD view-finder, connect it to a TV (via supplied cables), or upload the footage to your computer. Most cameras write the movie files in a QuickTime-compatible format, which means that you can play and edit the video on both Windows and Macintosh computers.

NOTE

Common movie formats on digital cameras include AVI, MOV, and MPEG-4. Currently, MPEG-4 enables the highest quality in the most compact files. If movie capture is an important requirement for your next digital camera, take a look at models that use MPEG-4.

For best image quality when shooting video, remember these tips:

Hold the camera steady during filming. Tripods are best for video shooting, but in a pinch, you can use your neck strap to stabilize the camera. Hold the camera out from your body until the strap is taut. Keep the camera in this position during filming, and it will help steady your shots. Also keep an eye out for posts, newspaper stands, fences, and

other items on which you can steady your camera. The world can be your tripod, if you're creative.

Shoot in good lighting. Even more so than still photography, video requires good lighting. If your scene doesn't have enough ambient light, consider adding some with an additional light source.

Frame your subjects tightly. Keep in mind that your movies are often only 320 pixels wide and 240 pixels tall to begin with, so you can't afford to stand too far back from the action, or your subjects will be ant-sized. Get close and shoot tight.

Your digital camera still won't replace a good video camcorder for top-quality recordings, but in a pinch it can capture special moments that you would otherwise have missed.

MPEG-4 Movie Format

Many of the newest digital cameras that record video as well as still pictures use the MPEG-4 format to compress those movies. MPEG (Moving Picture Experts Group) compression has been available for years in formats such as MPEG-1, MPEG-2, and now MPEG-4. This technology works its magic by storing only the changes from one frame to another, and not the entire frame itself. This enables much smaller file sizes than uncompressed formats, which is important when you're trying to squeeze full-size video onto a small digital camera memory card. See "Movie Mode" for more information about shooting video with your digicam.

Panorama Mode

Have you ever remarked to someone viewing your vacation pictures, "It sure looked a lot more impressive when I was standing there"? If you want to capture the breadth of a scene,

you most likely won't be able to fit all the grandeur into your camera's viewfinder—even at the wide-angle setting.

Panorama mode is a clever alternative offered by camera makers to help you capture the grandeur of big landscapes. You work the magic by photographing a sequence of images, then "stitching" them together later on your computer. Panorama mode prepares the sequence of shots for easy assemblage. Cameras that have this option also include the corresponding software required to make seamless final images. If your camera didn't come with stitching software, you can use Photoshop Elements, which is a terrific all-purpose image editor that costs less than $100.

PRACTICAL EXAMPLE

Tips for Shooting a Successful Panorama

Most panoramas require three to six images to achieve the full effect. When looking for good subjects, keep in mind that it's easier to create a seamless image when your subject is evenly illuminated. That usually means that the sun is to your back or off one shoulder. Avoid shooting directly into the sun for any of the frames in the sequence, at least until you're a little more experienced.

The next trick is to keep the horizon line as level as possible when you capture each frame in the sequence. Tripods help tremendously with this task, but you might not always have one with you. The next best solution is to become a *human tripod.* Here's how the technique works:

1. Hold the camera firmly with both hands so you can see through the optical viewfinder or LCD monitor.
2. Press your elbows against your body to create a steady support for the camera.

continued

Tips for Shooting a Successful Panorama

3. Compose your first picture, usually starting from the left side. Note the location of the horizon line, and make sure it's level.

4. Take the first shot. After the shutter has fired, don't move!

5. Continue to hold the camera in the locked-elbow position, and rotate your body a few degrees to the right to compose the next frame in the sequence. The only moving body parts should be your feet—everything else should be still as night. Make sure you have a 30% overlap from the previous image you shot-the computer uses this overlap information to stitch together the pictures.

6. Check the horizon line to make sure it's in the same location as in the last frame, and that it's still level.

7. Take the second shot. (Don't move afterward!)

8. Repeat this procedure through the entire sequence of shots.

9. Turn off panorama mode once you've finished the series.

With a little practice, you'll be able to employ the human tripod technique to create fantastic panoramas, without having to lug around your favorite three-legged friend (see Figure 2-18).

One last thing to keep in mind is that panoramas are stunning as large prints. Shoot these sequences at your camera's highest resolution so you always have the option to print them at maximum size.

Figure 2-18. This image of the Bay Bridge from San Francisco is actually six images "stitched" together

Partial Metering Area

See "Spot Meter."

Photo Effects

Many cameras allow you to apply creative effects—such as black and white, sepia tone, vivid color, and low sharpening—instead of recording standard color images. You can apply those effects when you take the pictures, using the camera's effects settings, or convert your standard color images on your computer after you've uploaded the images—it's your choice. Here are the most common effects modes and what they do (see the following practical example for some example photos):

Black and white Captures the picture as a grayscale image, eliminating all color.

Blackboard Underexposes the image, ensuring that a blackboard (with chalk writing) will appear black and not gray.

Low sharpening Softens the outlines of the subject. This is a good effect to experiment with for portraits. The effect isn't as strong as with a softening filter that goes over the lens, but this setting is effective.

Sepia tone Adds a warmish brown tone to the image. Unlike black and white, which is easy to apply on a computer, sepia toning is easier to use as an in-camera effect. You might want to take a second shot in full color as a backup.

Vivid color Enhances the color saturation of the picture. This can also be easily accomplished on a computer later, but this effect is handy because you can use your camera's LCD monitor to preview how a highly saturated image will look.

Whiteboard Overexposes the image, so you can use the digital camera to capture notes from a whiteboard or photograph posters with white backgrounds.

Image Effects Without the Software Investment

You can employ photo effects without waiting to get back to your computer. Figure 2-19 was captured in standard color mode, but you can take the same picture with a completely different look, as shown in Figure 2-20 with the sepia tone effect. You can even shoot in black and white, as illustrated in Figure 2-21. You can use your camera's black and white effect to preview how a picture will look, but I recommend that you capture the photo in color, then convert it to black and white on your computer. That way, you have both versions of the image.

Figure 2-19. Standard color mode

continued

Image Effects Without the Software Investment

Figure 2-20. The sepia tone effect

Figure 2-21. The black and white effect

Programmed Autoexposure

The most common method for setting the aperture and shutter speed for digital cameras is *programmed autoexposure*. On many basic models, this is the only exposure mode offered.

When using programmed autoexposure, all you have to do is "point and shoot." The camera's light meter "reads" the scene and compares the information gathered to data stored in the camera's electronics. The camera then selects the aperture/shutter speed combination that best matches the information recorded by the light meter.

The caveat is that the camera's electronics can be fooled, resulting in a less than perfect picture. See the "Exposure Compensation" entry for more information on how to adjust programmed autoexposure to handle tricky lighting situations.

The bottom line is that programmed autoexposure is a reliable tool for capturing good pictures *most* of the time. You can increase your odds by learning a few of the override controls, such as *exposure compensation*, *spot metering*, and *exposure lock*.

Protect Images

The Erase All command removes all images from your memory card. It's a handy way to clean house without having to remove each picture individually. What if, however, you wanted to remove all pictures except for one or two? The Protect Images option can help you do just that.

Display the first picture you want to retain on the LCD monitor, then choose Protect Images from the menu. An icon (such as a key) should appear on the monitor, to indicate that the picture is safe. Repeat for any other images you want to keep, and then use the Erase All command to delete the other images.

Be sure to practice this on test pictures to make sure everything works properly, or try it after you've already downloaded all the pictures you want to keep to your computer. Also, remember that Protect Images doesn't work when you use the Format Card command. With this command all of your images will be erased, regardless of whether they are protected.

RAW

See "File Formats (Still Images)." (Also see "Work with RAW Files" in Chapter 3.)

Resolution

By far one of the most important settings on your camera, *resolution* sets the pixel dimensions of your picture, thereby determining the size at which it can be displayed or printed later on. Most cameras allow you to set the resolution of the picture via the menu options.

If, for example, you select your camera's smallest pixel dimensions—say, 640 × 480—your picture will be adequate for web page display. But if you wanted to make a photo-quality print of that picture, you would only have enough resolution for a 3" × 4" print at best.

On the other hand, if you select your camera's maximum resolution, such as 2560 × 1920 pixels (on a 5-megapixel camera), you'll be able to make an 8" × 10" photo-quality print, or even a good 11" × 14" print, from the same picture. (See Table A-7 in the Appendix for more details.)

The trade-off is that the higher the resolution, the more room each picture occupies on your memory card. So, if you have a 5-megapixel camera with a 1-GB memory card, you'll be able to squeeze 461 pictures onto the card when the camera is set to its highest resolution (2560 × 1920 pixels). At medium resolution (1600 × 1200 pixels), your capacity increases to 854 pic-

tures. And at the smallest resolution (640 × 480 pixels), you can save a whopping 4,721 pictures to your card!

As tempting as 4,721 pictures may sound, remember that if you take that once-in-a-lifetime shot at 640 × 480, your once-in-a-lifetime print will be wallet-sized. On the other hand, if you shoot at 2560 × 1920, you'll always have the option of making a photo-quality 8" × 10" print, and if you just want to send images via email to friends and family, you can scale down your "master" image to a smaller resolution before mailing.

> **NOTE**
>
> For more information on preparing your pictures for email, see "Send Pictures via Email" in Chapter 3.

Self-Timer

The easiest way for you as the photographer to join a group shot is to use your camera's self-timer, which delays the triggering of the shutter (after you push the button) for 10 seconds or so. First position the camera on a solid surface or on a tripod, and then compose the picture. Before firing away, activate the self-timer. That way, when you push the shutter button, the camera will count to 10 before taking the picture, giving you plenty of time to join your friends. The self-timer is also valuable any time you want to shoot with minimum vibration to the camera.

One of the tricks to self-timer mastery is to make sure the camera's focusing sensor is reading the subjects and not the background. Be especially careful when using the self-timer for portraits of couples, because the sensor often reads the area right between their heads. If your camera has focus lock, you might want to use it. Using manual focus is also handy for these types of shots, but only advanced cameras offer this option.

Using the Self-Timer for Capturing Striking Night Shots

The self-timer can also be used as a substitute for a remote (or cable) release. This comes in handy for pictures that require the shutter to be open for a long time, such as a nighttime shot when the camera is on a tripod. By using the self-timer or remote release, you can trip the shutter without vibrating the camera. Some cameras make this even easier by providing you with a 2-second option to complement the standard 10-second delay. That way you don't have to wait nearly as long for the shutter to trip once you've activated the timer. This technique made the nighttime shot in Figure 2-22 possible.

Figure 2-22. Las Vegas is much more interesting at night—this shot was captured by steadying the camera and using the self-timer to trip the shutter without vibrating it

Sequence Shooting

See "Burst/Continuous Shooting Mode."

Shutter Priority Mode

See "Timed Value (Tv) Mode."

Spot Meter

This metering pattern enables you to "read" the exposure for a small area or "spot" in the viewfinder, usually five percent or less of the center of the frame. Not all cameras include a spot meter option, but those that do enable the photographer to set the exposure on an element in the composition rather than on the scene as a whole.

The most practical method for spot metering is to point the metering area at the object in the scene that is most important to you, then use exposure lock. You can then recompose the scene any way you want, knowing that the most important element in the picture will be exposed properly.

Some cameras have *partial metering* instead of a true spot meter. Partial metering behaves the same way as a spot meter, but the metering area is bigger. Spot meters usually read 5% or less of the viewfinder, while partial metering patterns typically read about 10%.

TIFF

Tagged Image File Format. See "File Formats (Still Images)."

Timed Value (Tv) Mode

Often referred to as *shutter priority*, this setting is commonly available on advanced amateur and pro-level cameras. Tv enables you to set the shutter speed and lets the camera figure out the corresponding aperture setting. A common use for Tv is for sports photography, in which the action is frozen with a "fast" shutter speed.

Tv is also useful for situations that demand a very slow shutter speed, such as to create a soft, dreamlike effect with running

water. Here are a few scenarios where you might want to switch to Tv mode:

Sports events A fast shutter speed of 1/500th or 1/1000th of a second will "stop the action." You'll need plenty of ambient light to use these settings. In a pinch, you can increase your ISO speed setting to 400 to make your camera more light-sensitive, but remember that you'll also gain image noise as part of the bargain.

Children playing outdoors A fast shutter speed of 1/250th or 1/500th of a second will help you record children at play. If you feel like you're missing good shots because of shutter lag (delay from the moment you press the shutter to when the picture is actually recorded), try using *focus lock* to shorten lag time. You may also want to turn on the fill flash (see "Flash Modes) and stay within 10 feet of your subjects. In addition to improving the lighting for outdoor portraits, the flash helps freeze the action.

Running water The effect you want determines the shutter speed you choose. If you want to freeze the water and see droplets suspended in air, use a fast shutter speed such as 1/250th or 1/500th of a second. If you're shooting a waterfall and want a soft, dreamlike effect (see Figure 2-23), select a slow shutter speed, such as 1/8th of a second. In this case, make sure you have your camera securely mounted on a tripod.

PRO TIP

If the scene is too bright for you to use a slow shutter speed, hold your sunglasses over the lens while making the exposure. Not only will this create a longer exposure, but you'll also get a nice polarizing effect as a bonus! If your camera does accept accessory filters, one of the best to have in your kit is a polarizer, which is much easier to use than holding sunglasses over the lens.

Streaking lights To show motion, use a very slow shutter speed, such as 2, 4, or even 8 seconds (if your camera provides those options). This method is particularly effective at twilight to capture cars' lights as they drive by. Again, mounting your camera on a tripod is essential. If you have a remote release, you might want to use it to prevent you from jarring the camera as you trip the shutter.

These examples don't cover every situation, but they will help you use shutter priority to create the effect you want when working with subjects in motion.

PRACTICAL EXAMPLE

Dreamlike Water Shots

The dreamlike quality of the running water in Figures 2-23 and 2-24 was captured using the timed value (Tv) mode. By using a slow shutter speed (2 seconds), the photographer was able to soften the appearance of the falling water. A tripod and a bit of patience are necessary to capture this type of shot.

Figure 2-23. Slow shutter speed resulting in a long exposure can make for magical shots of waterfalls…

continued

Dreamlike Water Shots

Figure 2-24. ...or rivers in motion

White Balance

Different light sources, such as tungsten light bulbs, produce light at different color temperatures than normal daylight (different temperatures often result in pictures that are "cooler" or "bluish" in some situations, or "warmer" or "reddish" in others). Your optical/nervous system compensates for these variations in color, but cameras need a little help as you move from outdoors to indoors.

Film cameras rely on color correction filters to capture natural tones under a variety of conditions. Digital cameras make things easier by providing a built-in *white balance* adjustment. This control not only allows you to capture pictures with accurate tones, but also enables you to preview the effect on your LCD monitor before you take the shot. Think of the white balance control as your own personal filter collection, built right into the camera.

The default setting for your camera is *auto white balance*. This mode works amazingly well most of the time. To test for yourself, point the camera at a different light source, such as a regular light bulb, and watch in the LCD monitor as the image slowly goes from very amber to a less surreal off-white.

Still, the effect produced by auto white balance may not always be exactly what you're looking for. In these instances, you can override the auto mode via one of the color correction presets available on your camera. Here's a list of the most common ones:

Daylight Used for general outdoor photography. Adds slight warmth to the coloring to offset a blue, cloudless sky.

Cloudy Helps correct overcast skies, but is also good for shooting in open shade, such as under a tree. This setting adds more warmth to the scene than the daylight selection.

Tungsten Adds a bluish tone to offset the reddish cast created by standard light bulbs.

Fluorescent Corrects for the greenish cast under warm-white or cool-white fluorescent tubes.

Fluorescent H Helps balance the color for daylight fluorescent tubes.

Figure 2-25 shows a typical white balance menu. The Cloudy white balance setting warms (adds red/yellow to) the tones in the picture. The Tungsten setting (represented by the light bulb to the right of Cloudy) cools (adds blue to) image tones.

Many intermediate to advanced cameras also include a custom white balance that allows the camera to find the right color correction when you point it at a white surface. Even better, some advanced digital SLRs, such as the Canon 20D, let you select specific hues via the Kelvin color temperature scale. If your camera has this capability, be sure to see Table A-9 in the

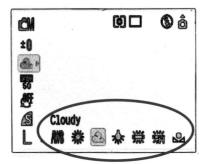

Figure 2-25. Typical white balance menu

Appendix for a complete listing of Kelvin degrees and their corresponding light sources.

PRACTICAL EXAMPLE

Using White Balance as a Creative Tool

Although white balance settings are designed to help you create colors that are as natural as possible, you can also use them creatively. For example, if you were shooting a portrait indoors next to an open window, you would normally choose the Cloudy setting to produce more natural skin tones. But what if you wanted to convey a more somber mood? By using the Tungsten setting, you could transform the ambient light to a bluish-colored hue, changing the mood of the entire shot.

In the case of a church interior, for example, you could take a photo using auto white balance (Figure 2-26) and then try Cloudy (Figure 2-27), and decide later which image best conveys the mood you want to express.

The white balance settings are both practical and creative tools for the digital photographer.

continued

Using White Balance as a Creative Tool

Figure 2-26. The auto white balance setting produces a cool interior

Figure 2-27. Changing the setting to Cloudy warms up the tones

One final thought on white balance: if you use the RAW format when capturing images, you can stick with the auto white balance setting, then fine-tune the color temperature later on your computer with the RAW image editor. I wouldn't recommend this technique as your default approach, but it is helpful in tricky lighting situations when you're having a hard time determining the right camera setting.

Zoom/Magnify Control

Most people are familiar with using the zoom lever (or buttons) to zoom in and out when composing images in picture-taking mode. But magnifying the picture you just captured on the LCD monitor for closer inspection is equally valuable.

The problem with LCD monitors is that they are very small, colorful, and sharp. What's wrong with that? If you don't "zoom in" when you review your pictures on these little screens, you might be misled as to the quality of your shots. In other words, LCD monitors make your pictures look better than they really are (conversely, you may miss small details that make one shot better than the next).

By using the magnify control to zoom in on your subject as you review a picture, you can get a better idea of its true quality. For example, you may want to take a closer look at the subject's face on the LCD monitor after you've shot a portrait. If you don't zoom in to check out the image, when you upload it to your computer you may find (much to your dismay) that the subject's eyes were closed. If you had used the magnify control right after you had taken the shot, you might have seen the closed eyes and continued the shoot.

Obviously, you don't want to employ the magnify control after every shot you take, or people will lose patience with you. But before you let your subject leave, take a few moments

to review a sampling of the images so you know you won't be disappointed when you get home and upload the pictures.

Putting It All Together

By now you've committed everything you learned in this chapter to memory, right? Well, probably not. That's why this book is a pocket guide and not a desktop reference. Keep it in your camera bag, backpack, or back pocket so you can refer to it over and over again.

As you continue to get comfortable with this information, you'll begin to use many of these functions in combination with one another to achieve the effect you want. For example, you may use both the white balance and exposure compensation adjustments to create a dark, moody indoor portrait. The next day, you may use the fill flash mode and aperture priority to shoot stunning bridal portraits at a wedding.

One of the great advantages of digital photography is that you can experiment with these settings, and it doesn't cost you a penny. Plus, you get immediate feedback from your efforts.

In Chapter 3, you'll start putting your camera knowledge to use as you learn many of the techniques that pros use to create great images. So recharge those lithiums, and let's get to it.

3 📷

How Do I…?
Tips and Tricks for Shooting and Sharing

By now, you and your digital camera have become fast friends and are working together to make great images. But as with the art of cooking, and life, there's always more to learn.

This chapter is more conversational than the previous two. The earlier sections of the book were designed for quick reference—to use while standing on the battlefield of photography and trying to survive. (Question: "Should I turn the flash on or off for my daughter's outdoor birthday party?" Answer: Flash on.)

But now the discussion becomes more free flowing, like a conversation between two photographers trying to decide the best approach for a given situation. The topics in this chapter focus on both shooting and sharing pictures—after all, what good is a great shot if you can't show it to others?

So grab a fresh memory card and a charged set of batteries, and prepare for the next stage of your journey.

Shooting Tips and Tricks: How Do I…

How do I…? Those are the first three words in any photography question, aren't they? Most of the time you know what you want to do: capture that sunset, take a pretty portrait, preserve the memory of that monument. The trick is making the camera see your subject the way you do.

That's what you're going to learn here: the "how to" of photography. Not every situation is covered in this chapter, but if you master these techniques, there won't be too many pictures that get by your camera. And when your friends mutter out loud something like "How do I shoot that object inside the glass case?", you can reply, "Oh that's easy. Just put the edge of the lens barrel against the glass to minimize reflections, then turn off the flash."

Take Great Outdoor Portraits

When most folks think of portrait photography, they envision studio lighting, canvas backdrops, and a camera perched upon a tripod. But many photographers don't have access to lavish professional studios, and honestly, it's not necessary for dynamite portraits.

All you really need is a willing subject, a decent outdoor setting (preferably with trees), and your digital camera, and you can be on your way to creating outstanding images.

First, start with the magic rules for great outdoor portraits:

Try adding supplemental light from the flash or a reflector.
Turning on the flash outdoors is a trick that wedding photographers have been using for years. If you really want to impress your subjects, position them in the open shade (such as under a tree) with a nice background in the distance. Then turn on the fill flash and make sure you're standing within 10 feet (so the flash can reach the subject). The camera will balance the amount of light from the flash with the natural background illumination, resulting in an evenly exposed portrait (see Figure 3-1). A variation on this technique is to turn off the flash and use a reflector to "bounce" the light back toward the model's face. The advantage here is that the reflected light is softer than that

from a fill flash (see Figures 2-1 and 2-15 for more examples of portraits using fill flash).

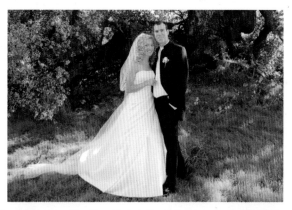

Figure 3-1. By putting the subjects in the shade, you can control the lighting. For this shot, a fill flash was used on top of the camera to illuminate the subjects with an even front light.

Learn to love high clouds and overcast days. High clouds turn the entire sky into a giant lighting softbox, and all of nature becomes your portrait studio. The diffused lighting is perfect for outdoor portraits, and it softens skin tones. In this situation, you have the option of shooting without a flash and reflectors. If you want to brighten up your model's eyes a bit, turn on the fill flash or use a reflector. One thing to remember when shooting in this type of lighting: change your white balance to Cloudy, or the skin tones may be too "cool."

Get close. The tighter you frame the shot, the more impact it will have. Extend your zoom lens and move your feet to create more powerful images. Once you've moved in close and have shot a series of images, get closer and shoot

again. I captured the shot in Figure 3-2 on about the sixth frame, just as the model had begun to relax.

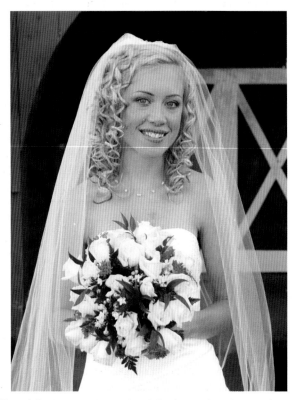

Figure 3-2. As you continue to shoot during the portrait session, move in closer for tighter compositions. Models typically relax as the shoot progresses, enabling you to capture more natural facial expressions.

Once you've found a setting that you like and have everything in order, you can begin to "work the scene." Start by taking a few straightforward shots. Pay close attention while you have

the model turn a little to the left, then to the right. When you see a position you like, shoot a few frames. (Don't get too carried away with this "working the angles thing," or your subjects will hate you. You're not a swimsuit photographer on a *Sports Illustrated* location shoot. The point is, don't be afraid to experiment with different camera positions. Just do it quickly.)

Next, move in closer and work a few more angles. Raise the camera and have the model look upward; lower the camera and have the subject look away. Be sure to take lots of shots while experimenting with angles, because once you've finished shooting and have a chance to review the images on your computer screen, you'll end up discarding many images that may have looked great on the camera's LCD monitor. When they're enlarged, you'll see bothersome imperfections you didn't notice before.

When shooting portraits, communicate with your subjects and try to put them at ease. Nobody likes the silent treatment from the photographer. It makes your subjects feel like you're unhappy with how the shoot is going.

Here are a few other things to avoid when shooting outdoor portraits:

Avoid harsh side lighting on faces. Light coming in from the side accentuates texture. That's the last thing most models want to see in their shots, because more texture equates to increased visibility of skin aging or imperfections. Use a fill flash or reflector to minimize texture, and avoid side lighting unless for special effect.

Don't show frustration. Never, ever make subjects feel it's their fault that the shoot isn't going well. They're already putting their self-confidence on the line by letting you take their picture. Don't make them regret that decision. When shoots go well, credit goes to the models. When shoots go

badly, it's the photographer's fault. Keep your ego in check so theirs can stay intact.

Avoid skimping on time or the number of frames you shoot. Your images may look good on that little 2" LCD monitor, but when you blow them up on the computer screen, you're going to see lots of things you don't like. Take many shots of each pose, and if you're lucky you'll end up with a few you really like.

Don't torture models by making them look into the sun. Yes, you were told for years to shoot with the sun to your back—but the photographer, not the model, devised that rule. Blasting your subjects' retinas with direct sunlight is only going to make them squint, sweat, and maybe swear. Be kind to your models, and they'll reward you with great shots.

Avoid busy backgrounds. Bright colors, linear patterns, and chaotic landscape elements will detract from your compositions. Look for continuous tones without the hum of distracting elements.

Now that the basics are covered, here are a couple of super Pro Tips. Make sure you have some good, solid shots recorded on your memory card before you start experimenting with these techniques. But once you do, try these suggestions:

Soft background portraits These are simply lovely. A soft, slightly out-of-focus background keeps the viewer's eye on the model and gives your shots a real professional look. The mechanics of this technique are described in Chapter 2, under "Aperture Value (Av) Mode," with an example illustrated in Figure 2-1.

Rim lighting for portraits When you place the sun behind the model, often you get highlights along the hair. Certain hair-

styles really accentuate this effect. Remember to use fill flash for this setup, or your model's face will be underexposed.

Set Up Group Shots

Many of the rules for engaging portraits apply to group shots, too, so keep in mind everything that you've learned so far while preparing for this assignment.

The first challenge is to arrange the group into a decent composition. If you've ever participated in a wedding, you know this drill. Avoid, if possible, having all of the heads in a straight line. This creates a static composition. Notice that in Figure 3-3 one of the subjects is positioned on the ground, avoiding the straight-line composition. Also resist the urge to center all of the subjects in the middle of the frame. You can create a little compositional dynamism by working the Rule of thirds (see "Composition" in Chapter 2).

Figure 3-3. Family group shots should not look like police lineups. Look for a pretty setting, and think creatively as you position your subjects. This portrait was shot in open shade, using a fill flash for supplemental lighting.

Remind everyone in the shot that they need to have a clear view of the camera. If they can't see the camera, then the camera won't be able to see them. Next, position people as close together as possible. Group-shot participants tend to stand too far apart. That might look OK in real life, but the camera accentuates the distance between people and the result looks awkward. Plus, you can't afford to have the shot span the width of a football field, or you'll never see people's faces unless you enlarge the image to poster size.

Remember to take lots of shots—for large groups, a minimum of five frames for each composition. This gives you a chance to overcome blinking eyes, sudden head turns, bad smiles, and unexpected gusts of wind ruining your pictures.

Before pressing the shutter button, quickly scan the group and look for little annoyances that will drive you crazy later: crooked ties, sloppy hair, and turned-up collars will make you insane during postproduction.

PRO TIP

Carry a stepladder for big group shots. When shooting groups of 10 or more, it's best to position your subjects on steps so you can stagger their heights and compose a more compact shot. But if steps aren't available, you can climb a few rungs on a portable ladder—elevating the camera gives you a better chance of capturing a clean shot of everyone's faces.

Finally, work quickly. You're not John Ford making the great American epic, so don't act like you are. Keep things moving for the sake of your subjects. (And for your own tired feet!)

Capture Existing-Light Portraits

By now you've probably realized one of the great ironies in good portrait photography: the flash is your friend when working outdoors. So guess what the great secret is for indoor portraiture? That's right; sometimes it's better to turn off the flash. Some of the most artistic portraits use nothing more than an open window and a simple reflector.

The problem with using your on-camera flash indoors is that the light is harsh and creates an image filled with contrast. "Harsh" and "high contrast" are two words models don't like to hear when it comes to picture descriptions.

Fill flash works outdoors because everything is bright. The flash "fills" right in. But ambient light is much dimmer indoors, and the burst of light from the flash is much like a car approaching on a dark street.

Of course, there are times when you have no choice but to use your camera's flash indoors. It's very convenient, and you do get a recognizable picture. But when you have the luxury of setting up an artistic portrait in a window-lit room, try existing light only.

First, position the model near a window and study the scene. You can't depend solely on your visual perception, because your eyes and brain will read the lighting a little differently than the camera will, especially in the shadow areas—you will see detail in the dark areas that the camera can't record.

This is why you'll probably want to use a reflector to "bounce" some light into the shadow areas. Many photographers swear by collapsible light discs, but a large piece of white cardboard or foam core will work just as well. Place your reflector opposite the window and use it to "bounce" the light onto the dark side of the model's face. This will help "fill in" the shadow area so you can see some detail.

Now put your camera on a tripod and slowly squeeze the shutter button. Review the image on the LCD monitor. If the shadow area is too dark, you may want to add another reflector. If the overall image is too dark, turn on exposure compensation, set it to +1, and try another picture. If the color balance of the image is too "cool" (that is, bluish), you may want to set the white balance control to Cloudy and see if that improves the rendering.

Remind your model to sit very still during exposure, because you may be using a shutter speed that's as slow as 1/15th of a second, or even longer. You can increase the camera's light sensitivity by adjusting the ISO speed to 200, but don't go beyond that setting—the image quality will degrade too much for this type of shot.

Once you've played with these variables, go back to the artistic side of your brain and work on the composition. Try to get all the elements in the picture working together, and let nature's sweet light take it from there. When it all comes together, existing-light portraits are magical (see Figure 3-4).

Take Passport Photos and Self-Portraits

Some people may think that turning the camera toward yourself is the height of narcissism, but sometimes you need a shot and no one is around to take it for you. Headshots for passport photos and résumés are typical scenarios for the emergency self-portrait. Start with the basics: make sure your hair is combed, your collar is down, your shirt is clean, and your teeth are free of spinach (and lipstick!).

Then find a location with a pleasing, uncluttered background. Put the camera on a tripod, and set it to focus on the area where you'll be standing or sitting. Activate the self-timer.

Figure 3-4. An existing-light portrait using window light from the left and a reflector positioned on the right.

If the room is too dim for an existing-light portrait, try using "slow-snychro" flash (see "Flash Modes" in Chapter 2 for more information). This type of flash provides enough illumination for a good portrait, but slows down the shutter enough to record the ambient light in the room.

Now position yourself where you focused the camera, and look directly into the lens. Don't forget to smile, or at least not to grimace. (Remember, you want governments to let you in to their country.) See Figure 3-5.

Figure 3-5. Try not to grimace when taking self-portraits.

REMINDER

Passport photos need to be cropped to 2" × 2", with a 1/2" space between the top of the head and the top edge of the photograph. The head needs to be facing the camera squarely, with a good view of the eyes and no distinct shadows covering the face. The background must be white or off-white, and the image must be printed on high-quality photo paper.

Take several shots, trying different poses until you hit on a few you like. If you have a remote release for your camera, you can save yourself lots of running back and forth from the tripod to the modeling position.

PRO TIP

Position a mirror behind the camera so you can better "pose" yourself at the moment of exposure.

Self-portraits are perfect for experimenting with different "looks," which you might feel more self-conscious about when someone else is behind the camera. You can try different expressions and poses and erase the bad ones, and the world will never know the difference.

Take Interesting Kid Shots

Children are a challenge for many consumer digital cameras, primarily because of shutter lag. In short, kids move faster than some digicams can react. But with a few adjustments, you can capture excellent images regardless of the type of camera you have.

One of the most important adjustments is to get down to kid level when shooting. This is "hands and knees" photography at its best, as shown in Figure 3-6. If you need to, get on your belly for just the right angle. Getting down to their level will instantly make your shots more engaging.

Figure 3-6. Go where the kids are to get good shots. Don't be afraid to get down on the ground, and once you're there you might want to turn on the fill flash to help you stop action and evenly illuminate the portrait.

Next, get close. Then get closer. This may seem impossible at times with subjects who move so fast, but if you want great shots, you've got to keep your subjects within range.

Now turn on the flash, regardless of whether you're indoors or out. Not only will this provide even illumination, but the flash helps "freeze" action, and you'll need all the help you can get in this category. Keep in mind, however, that the flash range of most digicams ends at around 8 feet.

Finally, use the "focus lock" technique described in the practical example "Capturing the Decisive Moment" in Chapter 2. By doing so, you can reduce shutter lag and increase your percentage of good shots.

Some of the most rewarding pictures you'll ever record will be of children. Like the child-rearing process itself, kid photography requires patience—but the results can far surpass the effort.

Capture Engaging Travel Locations

Make sure you pack a spare memory card and extra batteries when you hit the road with your digital camera. These compact picture-takers are perfect travel companions, but you don't want to run out of storage space or juice halfway through your trip.

When you're on the road, approach your travel photography the same way a director thinks about filming a movie scene. The first frame, often called the *establishing shot*, is of the point of interest itself, such as an old church. The second image is a nicely framed portrait, with an *element of the structure* included in the picture. If the subject warrants it, you might even want to move in very close for a third shot, or several follow-ups.

Why multiple shots? For the same reason that moviemakers use this technique. If you try to tell the whole story with just

establishing shots (see Figure 3-7), your viewers may soon lose interest in the presentation, and you may miss interesting details. That's the problem with so many vacation shots—they're taken at too great a distance.

Figure 3-7. A beautiful landscape shot helps establish the mood of your travel location.

On the other hand, if all of your travel compositions are tightly framed (see Figure 3-8), your viewers won't know the difference between Denmark and Detroit. By using the multiple-shot approach, you establish both the setting and the detail of each location. This method is particularly effective when building slideshows.

Figure 3-8. But don't stop there! Be sure to photograph details of the area too. This will make your presentations more compelling.

PRO TIP

Don't forget to take pictures of signs and placards. It's a lot easier than taking notes about locations, and the information comes in very handy when recounting your travel experiences. Signs can also be a source of humor for your presentation—you never know what some people are going to post in public! (See Figure 3-9.)

continued

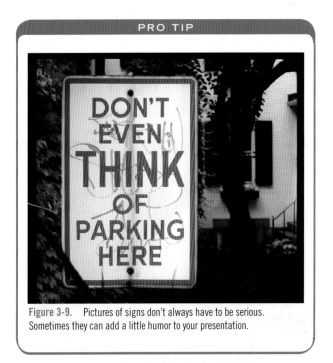

Figure 3-9. Pictures of signs don't always have to be serious. Sometimes they can add a little humor to your presentation.

Take Pictures at Weddings

Weddings are portrait heaven. Your subjects look sharp, are happy, and are in pretty settings. All you have to do is have your camera ready for the opportunities as they present themselves. Here are a few tips for great wedding shots:

1. Rule one is to not interfere with the hired photographer's shots. If you want to "follow in his wake" for special posed portraits, simply ask permission to shoot a couple of frames after he finishes. Most pros will accommodate these polite requests.

2. Next, turn on your flash and leave it on, indoors or out. See "Flash Modes" in Chapter 2 for an overview of your options and how to use them.

If your camera accepts an external flash, consider getting a *flash bracket* to elevate the light source above the camera. A dedicated cord connects the flash to the camera's hotshoe. Elevating the flash eliminates red eye and moves distracting shadows out of the frame.

3. When you're taking group shots, remember to position your subjects as close together as possible. Generally speaking, people stand too far apart. Tightening up the spacing will make for better shots.

4. Make sure everyone in the group has a clear view of the camera. If they can't see the camera, the camera can't see them. The choice for large groups is simple: either vary the heights of those in the group by arranging them on steps or risers, or raise the camera angle above their heads and shoot downward. If you have to, stand on a stable chair to get a better angle for group shots.

5. Keep an eye out for candids, too, as shown in **Figure 3-10**. Look for those special moments that make these gatherings so memorable—last-minute preparations, a kiss on the cheek, a sleepy child in a guest's arms, the perfect toast, a romantic dance sequence, or guests signing the guestbook. These are all potentially great photographs, just waiting for you to shoot them.

Finally, don't forget to include props in the shots when they're available. A hint of wedding cake in the background or a beautiful flower arrangement could be the frosting that adds the perfect finish to your portrait.

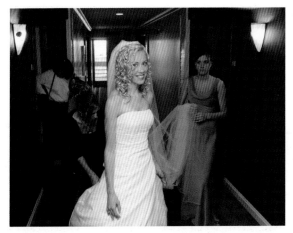

Figure 3-10. Even if you're not the hired photographer, there are plenty of opportunities for capturing pleasing images at a wedding. Just follow the action and have your camera ready.

Prevent Red Eye

Your subjects are vulnerable to red eye in dimly lit rooms when their pupils are open wide. The effect is actually caused by the light from the flash bouncing off the retina and being reflected back into the picture-taking lens. Point-and-shoot cameras are notorious for causing red eye, because the flash is so close to the lens; this makes for a perfect alignment to catch the reflection from the retina.

Even though many cameras provide a setting to reduce red eye (see "Flash Modes" in Chapter 2), they don't always work well and actually can be irritating to both subject and photographer. Instead, try following these suggestions when shooting in low light:

- Have the model look directly at a light source, such as a lamp, before taking the shot. This will constrict the pupils and reduce red eye.

- Turn up the room lights if possible.
- Shoot off to the side of the subject, or have the model look a little to the left or the right of the camera, not directly at the lens.
- Use an external flash mounted on a bracket. This is how wedding photographers cope with this problem. It works by changing the angle of reflection from the retina.
- Try an existing-light portrait, if the conditions are suitable.

If all else fails, you can touch up the photograph in an image editor after uploading it to your computer. It's not a perfect solution, but thanks to friendlier computer technology it's easier than it used to be. (For help with touching up red eye, try *iPhoto 5: The Missing Manual* or *Photoshop Elements 3: The Missing Manual*, both from O'Reilly and Pogue Press.)

Take Pictures from the Stands at Sporting Events

Speaking of the flash, how many times have you seen hundreds of cameras firing off from the stands during a sporting event in a large stadium? Alas, what a waste of film, battery power, and space on memory cards.

The flash range of most point-and-shoot cameras is about 10 feet. That means that if you're shooting from the stands, you're illuminating a couple of rows of seats in front of you, and that's about it. Instead, *turn off your flash* and use existing-light techniques. If you can adjust your camera's ISO setting (see "ISO Speed" in Chapter 2), bump it up to 200 or 400. This will increase your camera's light sensitivity.

When you take the shot hold the camera very steady, because the shutter speed will be slow and you'll want to minimize camera shake, which degrades image quality. Better yet, use a tripod if the situation allows.

Even if you hold the camera steady, the action on the playing field will blur, so try to make your exposures right after, or before, the action.

Obviously, you're not going to get *Sports Illustrated* shots from the cheap seats. But for memorable occasions, such as your hometown team winning the NCAA championship, it's great to have a few well-exposed images from the event to keep in your scrapbook.

Capture Action Shots

The keys to capturing effective action shots are to shoot at your camera's highest resolution, use a fast shutter speed, and take measures to reduce shutter lag (see Figure 3-11).

Figure 3-11. Two of the most important techniques for stopping action and capturing the decisive moment are to use a fast shutter speed (1/350th of a second for this shot) and to enable burst mode, which allows you to fire off a rapid series of frames. You can then pick the best image from the sequence.

Following these suggestions will improve the quality of your action shots:

1. First, set your camera at its highest resolution. You will probably want to crop your image later to bring the action closer. Having extra pixels actually extends the reach of your lens, which is very helpful for this type of photography.

2. The key to "stopping action" is to use a fast shutter-speed setting. Typically, you should use a speed of at least 1/250th, 1/500th, or 1/1000th of a second. The programmed autoexposure mode on most digital cameras is calibrated to give you the fastest shutter speed possible, so you don't need to monkey too much with your camera settings when going after action shots.

 However, what you really need is lots of light. The brightest hours of the day are best (usually from 9:00 a.m. to 4:00 p.m.). Shooting outdoors during these times should produce shutter speeds of 1/250th of a second or faster. If your camera has shutter priority mode, you can set the speed yourself and let the camera handle the corresponding aperture setting.

3. Unfortunately, a fast shutter speed doesn't help you overcome the lag time between the moment you press the picture-taking button and when the shutter actually fires. *Shutter lag* is the nemesis of point-and-shoot action photographers, and overall, it's the number one complaint about consumer digicams. Even inexpensive digital cameras should offer two features that can help you combat shutter lag:

 • The first is *burst mode*, which allows you to take a rapid sequence of shots. If you start the sequence right as the action is initiated, your odds of capturing the decisive moment are much higher. (See "Burst/Continuous Shooting Mode" in Chapter 2.)

- The other trick is to "preset the focus," thereby disabling the autofocus system and shortening the lag time between pressing the picture-taking button and actually recording the picture. The best way to do this is to use a function called *infinity lock*. The camera then "locks in" the focus at infinity, which provides you with a focus range from about 10 feet to the horizon. Once infinity lock is engaged, you can fire at will, without relying on your camera's autofocus system. (Sometimes you have to switch to landscape mode to activate the infinity lock. This doesn't seem intuitive, but often it works.) For more information on this function, see the "Infinity Lock" section in Chapter 2.

PRO TIP

If there's not enough light to use a fast shutter speed to stop the action, increase your ISO speed setting to 200 or 400. You'll gain a little image noise in the bargain, but it might be worth the trade-off to get a better shot.

Another helpful technique for action shooting is called *panning*, in which you "follow" the moving subject during exposure. Using this technique may feel odd at first, because you're taught to always hold the camera as still as possible when taking the picture. But panning can provide stunning results—if you follow the subject accurately, it will be in focus while the background displays motion blur. This effect gives the photograph great energy and a sense of movement.

The classic panning exercise is to have a bicyclist ride by while you keep the camera fixed on the rider during exposure. Use focus lock and burst mode to give yourself the best odds for timing the shot correctly. You might not be able to fully appreciate the effect on your small LCD monitor, but when

you upload the images to you computer you'll see a wonderfully blurred background providing the sensation of motion. Give it a try!

Shoot in Museums

Museums, aquariums and natural habitat parks provide opportunities for unusual shots. They also present some difficult challenges for the digital photographer, but nothing that can't be overcome with a little ingenuity.

Before you get too excited at the prospect of shooting beautiful works of art in a museum, be sure to ask if it's OK. Often you'll discover that photography is allowed in some areas, but not in others. To avoid embarrassing confrontations, ask when you first enter the facility.

Even when you're granted permission, you'll probably be told that you can't use a flash or set up a tripod. So here are a few tips to help you work around those constraints

1. Check your white balance. Chances are your images are displaying a noticeable reddish hue on your LCD monitor. Try using the Tungsten setting to improve the color balance. Some cameras allow you to set a custom color balance. You might want to give that a try if the presets don't provide the results you want. For more information, see "White Balance" in Chapter 2.

2. Find a way to combat the low ambient light often found inside museums. Chances are the camera shake symbol is flashing on your LCD monitor, telling you that your pictures are going to be "soft" due to a slow shutter speed.

 If your camera has a neck strap, you can use it to help you steady the shots. Pull the camera out from your body until the strap is taut. Use this resistance to steady your hands as you make the exposure. If one is available, you can also lean against a wall or pillar to help you combat camera shake.

As a last resort, you can increase your camera's light sensitivity by adjusting the ISO speed setting. Changing the setting to 200 or 400 might get rid of the camera shake warning, but your picture quality won't be as good. For more information, see "ISO Speed" in Chapter 2.

Regardless of the type of museum you're visiting, you're probably going to encounter exhibits behind glass. The trick to eliminating unwanted reflections is to put the outer edge of the camera's lens barrel right up against the glass, hold the camera steady, then shoot (make sure the flash is turned off!). By putting the lens barrel close to the glass, you eliminate those nasty room reflections that often ruin otherwise beautiful shots. (See Figure 3-12.)

Figure 3-12. Museum shooting often means shooting through glass. You can either put the camera lens right up against the glass, or stand back and compose the shot so you don't get any unwanted reflections. Either way, turn off the flash.

When you upload the pictures from your visit to the museum, you'll probably notice that many of the images suffer from softness and other flaws that you didn't detect on the LCD monitor. Don't despair, though—even if only a fraction of your images survive, they'll be treasured for years to come and are well worth the effort of capturing.

Shoot Architecture Like a Pro

Adding pictures of buildings and their interesting elements to your travel portfolio brings another dimension to your presentations. Point-and-shoot cameras aren't ideal for architectural shooting, but if you follow these suggestions, you'll be surprised by the results you can achieve.

You may have noticed a phenomenon called *converging lines* when taking pictures of large buildings. Instead of the structure standing straight and tall, the lines of the building slant inward so it looks like it's falling backward. This effect becomes more pronounced the more you angle your camera upward to compose the shot. To some degree this is a natural effect that viewers accept. Even in real life, looking upward at a tall building creates converging lines. We don't think about it much, but it can detract from your photos.

If you want to lessen this effect, there are a few things you can do. If you can get some distance from the building, you'll find that you don't have to hold your camera at such a severe angle, which will minimize the convergence of lines. You can zoom in with your lens if necessary to tighten the composition. You can also elevate your position, such as shooting from an upper floor of a building across the way, as in Figure 3-13. This allows you to hold your camera relatively parallel to the structure, which again lessens the effect. Digital SLR shooters who are serious about architectural photography might consider rent-

ing a "tilt shift" lens that is specially designed for this type of shooting. The Nikon 28mm f-3.5 PC Nikkor AI-S and the Canon TS-E 24mm f-3.5L are two examples of lenses that allow for shift movements, enabling you to minimize the effect of converging lines.

Figure 3-13. Tall buildings standing straight, thanks in part to the plane of the camera being relatively parallel to the plane of the structures. In this case, the picture was taken from an upper floor of a hotel.

But don't limit yourself to shooting only the big picture: architectural elements are often just as interesting (if not more so) than the complete structure. Look for interesting designs around windows, over doors, and along the roofline. Zoom in on specific areas that interest you, as in Figure 3-14, or elements that you might have missed during casual observation. To enhance textures and depth, look for "side lighting," which often provides more interesting images than flat front lighting. And don't forget to grab a couple of snaps of signs and placards to help you tell the story once you return home.

Figure 3-14. A church shot in morning side lighting.

PRO TIP

Side lighting is good for buildings because it enhances texture, but not so good for people, for the same reason.

Shoot Items Using Tabletop Photography

There are two ways to shoot items using tabletop photography: the hard way and the easy way. The hard way involves multiple studio lights, softboxes, umbrellas, and seamless backdrop paper. Professionals use this equipment to produce

outstanding images for commercial advertising and high-end editorial work.

But if you just want a nice picture of your old 35mm camera to sell on eBay, you probably don't want to set up an entire studio. So here's the easy way:

1. Find a window that you can set up a table next to. North-facing windows are great, but not necessary for this type of shooting. Cover the surface of the table with white paper, and if you can, create a white backdrop too. This will be your work area.

2. Put your camera on a tripod (or another stable surface) and adjust it so it's facing the item that you want to photograph on the table. Move both the subject and the camera to achieve the best lighting possible via the open window. Once everything is in place, make a tabletop reflector out of white cardboard, or cardboard (or another rigid material) covered with aluminum foil. Position the reflector opposite the light source (window) so it bounces light onto the shadowy side of the item.

3. Set the white balance to Cloudy (see "White Balance" in Chapter 2 for more information) and put your camera on self-timer (see "Self-Timer" in Chapter 2). Now trip the timer and stand back. After 10 seconds or so, the camera will take the shot for you to review. Continue refining your setup until you get the shot you want.

This simple setup can produce studio-like results with a fraction the cost or effort. Give it a try.

Create Powerful Landscape Images

You could spend your entire lifetime studying how to make great landscape images. There are, however, a few key techniques that will improve your nature shots right away while you learn the subtleties of the craft. Keep these few tips (demonstrated in Figure 3-15) in the back of your mind while shooting.

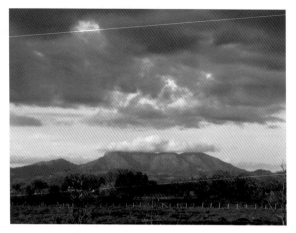

Figure 3-15. This image employs a few helpful landscape techniques. First, the horizon line is low in the frame, allowing for a "big sky." There are dark tones at the top and bottom of the frame that lead the eye to the brighter tones in the middle third of the composition. The image was recorded in late afternoon, taking advantage of "magic light." Finally, the picture was shot at high resolution, allowing for some cropping to fine-tune the composition.

Work with "magic light." Landscape pictures shot *before 9:00 a.m.* and *after 5:00 p.m.* look better, especially with digital cameras that have a hard time taming harsh midday sun.

Keep your compositions simple. Clutter is the bane of powerful landscape imagery. Look for simple, powerful compositions, and skip the rest.

Don't put the horizon line in the middle of the frame. Landscapes become more powerful when the horizon line is in the lower or upper third of the composition. You can create a very dynamic composition by putting the horizon very low in the frame and letting sky dominate the scene.

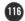

Look for converging lines to give the eye a path to follow. A diagonal line adds energy to the composition and can help lead the eye to a primary point of interest.

Alternate dark and light tones. This is a technique that Ansel Adams used quite effectively, finding a dark tone for the bottom of the frame, then a light tone, then another dark area (usually a shadow of some sort), then bright again, and possibly dark again at the top of the frame. Alternating tones adds plenty of visual interest.

Use a tripod when possible. By keeping your camera rock steady, you will squeeze every bit of sharpness out of the lens, rendering even the tiniest elements with clarity. Plus, photographers who use tripods tend to study their scenes more and have more refined compositions.

Be patient. Sometimes you have to wait for nature to paint you the perfect picture. Allow enough time to stay put for a while and watch the light change.

Use a polarizing filter. If your camera accepts accessories such as auxiliary lens and filters, consider adding a polarizing filter to your bag of tricks. Polarizers remove unwanted reflections, deepen color saturation, and bring an overall clarity to the scene. The effect is strongest when the sunlight is coming into the scene from over your shoulder.

Protect against lens flare by shielding the front glass element of your camera from the sun. Lens flare is that demon that degrades the color saturation of your images. Lens hoods were once standard issue for 35mm cameras, but no one seems to use them for digitals. To improve the quality of your shots, make sure the sun is not reflecting off the front of your lens. If it is, shield it with your hand, or better yet, this book, which is a perfect size for the job.

Shoot at the highest resolution and sharpness your camera allows. Landscapes look best when printed big, but to do so you need all the resolution your camera can muster.

Get out and walk. If you see a good shot from the seat of your car, chances are it's even better a few hundred yards away from the road.

Don't increase your ISO speed setting to cope with low light. Bumping up your speed will degrade the quality of your image. Use a tripod and your self-timer instead.

By keeping these tips in mind, and by reviewing the section "Composition" in Chapter 2, you can begin mastering the craft of landscape photography with your digital point-and-shoot camera, and take some great shots while doing so.

Shoot Infrared Images

Infrared photography has been around for a long time, but capturing these stunning pictures on film required true perseverance. Digital imaging has changed all of that. Shooting infrared photos, such as the one shown in Figure 3-16, has never been easier or more fun.

When you shoot infrared, you're actually dealing with a spectrum of light that's outside our normal range of perception. But with the assistance of a special filter, such as an IR 87 or Hoya R72, many digital cameras can produce the telltale dramatic effects, including a darkened sky, vivid clouds, and foliage emitting an eerie glow.

But not all digital cameras see the infrared spectrum equally. Ironically, as manufacturers made improvements in color fidelity, they often compromised the camera's infrared capability. For example, the older Canon G1 records fantastic infrared, but the newer models don't work quite as well. (This

Figure 3-16. This infrared image was captured at mid day, using a Canon G1 with a Hoya R72 filter attached. Because the filter is so dense, the shutter speed was a slow 1/3 of a second.

is a good argument for holding on to your previous cameras after upgrading.)

If you want to test your digicams to see which one will work the best for this type of shooting, line them up on a table in a darkened room. Enable picture-taking mode and make sure the LCD monitor is on. Then point your television remote control at each lens and press a control button, such as the channel changer. The camera that shows the brightest light emitting from the remote control will be your best infrared capture device.

Attach an infrared filter such as the Hoya R72 to your camera, grab your tripod, and look for a brightly lit scene that has sky, clouds, and trees. Set your aperture at f-5.8 or f-8 to help compensate for the different way infrared "sees" the world; the focusing plane in this type of photography is slightly different, and the added depth of field produced by a smaller

aperture will help keep things sharp. Be sure to turn on the self-timer so you don't jar the camera during exposure, and record a frame. The world you see in your LCD monitor will look much different from what you observe with your eyes.

Take Flash Pictures of People Who Blink at Flash

Every now and then you'll run into someone whose eyes are very sensitive to flash and who has a knack for blinking right as the flash fires. The result is a series of unflattering facial expressions and lots of frustration.

One of the best tricks to help calm the nerves of model and photographer alike is to use the red eye reduction mode. (See "Flash Modes" in Chapter 2 and "Prevent Red Eye" earlier in this chapter for more information.) The pre-flash that is designed to reduce red eye will actually cause the model to blink early, so her eyes will be open when the exposure takes place. It works almost every time.

Computer Tips and Tricks: How Do I...

You've just returned from a great two-week vacation, and your memory cards are bursting at the seams with photos and digital movies. Now what do you do?

Before you spam every friend and relative you know with mega-megapixel masters, take a few minutes to learn about

sampling down images so they have smaller file sizes. You'll also want to archive your pictures so you can find them again months later, when you want to relive the great memories. And what about those video snippets you have on your memory card? With a little editing, you can turn them into short movies.

In other words, this section will help you keep your friends happy and your pictures organized, and show you how to transform your video clips into real movies.

Send Pictures via Email

One of the first things that new digital camera owners love to do is send a batch of images to family members or friends. As you may have already discovered yourself, the warmth of reception is inversely proportional to the size of the images that land in your recipients' inboxes.

All too often, budding photographers send full-sized 2-, 4-, or even 6-megapixel pictures as email attachments. Unfortunately, these files take forever to download on all but the fastest Internet connections and are too large to view comfortably on a computer monitor.

Indeed, you should shoot at your camera's highest resolution, but remember not to send those full-sized images to others. All parties concerned will be much happier if you create much smaller "email versions" of your pictures and send those along. This technique is called *sampling down*. Here's how it works:

1. Use your image editor to resize *a copy of the image* for easier handling. To do so, use the "Save As..." command in your image editor. The largest size you should send as an email attachment is 800 × 600 pixels, and 640 × 480 pixels will usually do the job.

2. If you're lucky enough to have Photoshop (or Photoshop Elements) as your image editor, use the *Image Size*

function (see **Figure 3-17**) to resize the picture. (Other image editors have similar functions.) When you first open the Image Size dialog box, you'll see the current width and height of the picture. In the settings in **Figure 3-17**, those dimensions are 2272 pixels wide by 1704 pixels tall. This shot was taken at full resolution with a 4-megapixel camera. If you sent this picture as-is, the file size would be well over 1 MB even after compression, and a full 11 MB when opened. That's not the kind of attachment you want to send to friends and family.

Figure 3-17. The original dimensions of your picture will appear in the Image Size dialog box in Photoshop.

3. Use this dialog box to reduce the width and height settings to 640 × 480 pixels (or thereabouts). In the above example, these changes shrank the compressed file size to under 300 KB—just a fraction of the size of the original image!

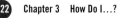

4. Make sure you have both the "Constrain Proportions" and "Resample Image" boxes checked when preparing image copies for email. With the "Constrain Proportions" box checked, Photoshop will automatically change the height dimension for you when you change the width. Photoshop users can also take advantage of the *Bicubic Sharper* algorithm, which you can select from the drop-down list next to "Resample Image." Since sampling down sometimes "softens" your pictures slightly, many photographers feel the need to sharpen the images after resampling. You won't need to use that two-step process if you select Bicubic Sharper—Photoshop will resample and sharpen for you in one step. (See Figure 3-18.)

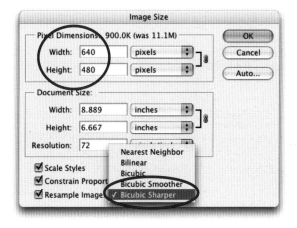

Figure 3-18. Appropriate dimensions for emailing pictures entered into the Image Size dialog box in Photoshop. Notice that Bicubic Sharper is selected for resampling—this sharpens and samples down at the same time.

"Resampling" is probably one of those words you've heard before but don't quite understand the meaning of. In simplest terms, resampling means that the image editor is either adding pixels to the image or subtracting pixels from the image. Usually you'll want to avoid "sampling up" (that is, adding pixels), because that degrades image quality. But "sampling down," or subtracting pixels, is a great way to reduce the file sizes of image copies that you want to send via email or post on the Web. In other words, when you change the width and height dimensions to smaller numbers, such as 320 × 240, you're sampling down, and both the picture and the file size will be smaller.

If you have a choice, the best image format to use for email attachments is JPEG (*.jpg*). When you save in this format, your computer will usually ask you which level of compression you want to use. Generally speaking, *medium* or *high* gives you the quality you need.

Remember to keep your original image safe and sound so you can use it later for printing and large display. To help eliminate confusion when dealing with these different sizes, you might want to save two copies, calling the original something like *vacation one hires.jpg* and the more compact version *vacation one lores.jpg* ("hires" being short for high resolution and "lores" denoting lower resolution).

If you send friends and family smaller, more manageable pictures, you'll hear more about how beautiful your shots are and less about how long the darn things took to download.

Share Pictures on the Web

A popular way to electronically share pictures these days is via online photo services that publish web page galleries of your images. Only a few years ago, setting up an online gallery was a cumbersome process requiring some knowledge of web page design. But easy-to-use online services such as Flickr (*http://www.flickr.com*) have streamlined this process so that anyone with an Internet connection can publish photos.

In addition to sharing pictures, these services allow you to write short captions, add titles, and even include "tags" that serve as keywords allowing you to easily find specific types of photos, such as landscapes. Once you've uploaded your pictures to the online service, you can notify all of your friends and family via email. The advantage of this method is that you're only sending them a text link to your photo web page, not actual images that they'll need to download. Also, since the photos are on the service's computer, they won't take up your viewers' valuable hard disk space.

Another advantage of this approach is that viewers can often post comments to accompany the pictures for everyone to read. So, for example, if you've published images from your sister's wedding, everyone in the family can remark on how beautiful she looks and which ones are their favorite shots. This type of photo sharing enables people all over the world to participate in the experience, just as if they were all sitting together around the kitchen table with an open photo album.

Some printing services, such as Kodak's EasyShare Gallery (*http://www.kodakgallery.com*) and Shutterfly (*http://www.shutterfly.com*), provide free online sharing with the added benefit that visitors can order prints from your galleries and have them shipped directly to their homes. They can even use those images to create calendars, personalized coffee mugs, and greeting cards.

Online photo-sharing services have become as easy to use as taking the pictures themselves. If you find yourself spending a lot of time emailing photos to friends and family, take a look at Flickr, Kodak EasyShare, Shutterfly, and other offerings.

Get Photo-Quality Prints

There are a variety of ways to get photo-quality prints from your digital images. You can make them yourself with a printer at home, or have a photo finisher do the work for you.

Many camera stores offer photo finishing from digital images. Simply take in your memory card, order the prints, and pick them up the next day. This service is now available in most drugstore chains, too—instead of dropping off a roll of film while running your errands, you leave them your memory card instead.

You can also order prints through online services such as Shutterfly (*http://www.shutterfly.com*). You have to upload your pictures via the Internet to their facilities; they send you your prints back through the mail. If you don't want to wait for the postal service, you can still place your print order via the Internet, then go directly to the camera shop or drugstore to pick up your prints, usually within 24 hours.

Printing at home has also become easier and more enjoyable, because when camera companies realized that it was a lot easier taking pictures than printing them, they began to take steps to overcome the printing hurdles. Today's inkjet printers are great for photo work, thanks to custom paper trays, memory card slots, PictBridge compatibility, and sometimes even LCD screens for previewing images. Now you can bypass the computer altogether to produce snapshots and enlargements. This technique is called *direct printing*.

There are two common ways to direct print now, and a third is evolving. The first method is to connect your camera to the

printer via its USB cable. Both camera and printer must have either *Direct Print* or *PictBridge* capability, but these technologies are built into nearly every camera and printer sold today. After you connect the two devices, you view the images on your camera's LCD monitor. When you find one you want to print, set up the job via the menu options on your camera and hit "print," and within minutes you'll have transformed a digital image into a beautiful snapshot.

Some printers include memory card slots, enabling you to remove the camera from the equation altogether. This method isn't as easy to use as the camera-to-printer connection, though, unless the printer also has an LCD monitor for previewing the pictures and setting up the jobs.

The third method of direct printing doesn't require a USB cable for the camera and printer to communicate. Instead, the print jobs are set up and transferred wirelessly, via either Bluetooth or WiFi (802.11). This method isn't as common yet, but it has great potential, especially for those who have a hard time keeping track of USB cables.

When shopping for photo printers, take a look at a popular alternative called *dye-sublimation thermal printers*, often simply referred to as *dye-sub printers* (see Figure 3-19). Instead of spraying ink onto the paper as inkjet printers do, dye-subs use heat to apply dyes to the printing surface. The advantage of this system is that the prints are more robust and more resistant to water damage and fading over time. Many manufacturers tout 100-year lifetimes for their dye-sub prints.

This durability is further enhanced by a protective overcoating that's applied at the end of the printing process, so not only will the prints last longer than their inkjet counterparts, but they're also protected from fingerprints. If little Johnny puts his sticky thumb on your dye-sub print, you can just wipe off the smudge.

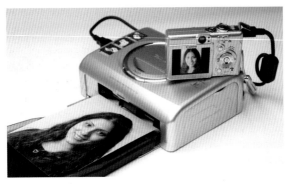

Figure 3-19. Portable dye-sub printers make producing a snapshot almost as fun as taking the picture itself. This Canon dye-sub has its own battery, so you can create prints just about anywhere.

The most popular dye-sub printers are the compact models that produce 4" × 6" snapshots. They're not much bigger than the cameras they connect to, often have their own batteries for portability, and print fantastic-looking snapshots. Now you can take your printer, as well as your camera, on vacation.

Present a Digital Slideshow

Slideshows are an age-old photographic tradition. Digital cameras make it easier than ever to present your images to many people at once.

Most digicams have a "video out" capability that lets you connect your camera directly to a television for playback on a large screen. If your camera has this functionality, it most likely has a slideshow mode that allows you to choose images that are stored on the memory card and present them on the television in timed intervals. All you have to do is turn on the stereo for some background music and add a little witty

commentary, and you'll have a full-fledged multimedia presentation to share with others.

Another option is to use the software that comes with your camera to assemble slideshows on the computer, then either show them on the computer monitor or connect the computer to a television for big-screen presentations. Computer slideshows have the advantage of enabling you to add transitions and special effects to your presentations. They can also be saved and played long after the memory card has been erased and reused.

You can also use independent software that didn't come with your camera for this purpose. Apple Computer's iPhoto not only enables you to make slideshows from your digital images, but also allows you to incorporate music directly into the presentation. You can even save the show as a QuickTime movie and send it to others.

Regardless of which method you use to create your presentations, keep in mind these basic tips that will help make your shows engaging and leave your audience begging for more:

- Include only your best images.
- Tell a story with your pictures as well as with your words.
- Keep your presentations short—5 to 10 minutes is all the time that's usually needed, or wanted, by your audience.
- Add music and anecdotes for more interest.
- Be creative. Add close-ups, distance shots, low angles, and high angles for variety.
- Never apologize for your pictures. If you don't think it's good enough to be in your show, don't include it.

Slideshows have never been easier to create, and people do like them when they're done well.

Work with RAW Files

One of the great debates among advanced digital photographers is whether to use the JPEG or RAW format for recording images. Both formats are capable of producing high-quality pictures, but when you shoot in JPEG mode, the camera processes the image for you so it is "complete" when you upload it to your computer.

Images captured in RAW format, on the other hand, are not complete when you transfer them to your workstation. This process is more like taking a negative into a darkroom, where you can adjust the white balance and exposure until you get the perfect image. It's true that you can make those same adjustments in post-production with JPEGs, but it's different because you're readjusting information that's already been set. With RAW, you are actually mapping the original bits of information.

One of the battle cries of this book is "Good data in; good data out." The better you capture your shot, the easier it will be to produce high-quality output. Shooting in RAW mode means you can delay some difficult decisions until you're in the comfort of your own home, working at your computer.

A good example is determining the correct white balance, which is often difficult at the moment of exposure (especially under fluorescent or mixed lighting). When you shoot in JPEG mode, you have to make an immediate decision, and if you're wrong, you have to figure out how to correct it later.

In RAW mode, it doesn't make as much difference which white balance setting you select when you shoot the picture. The camera just records the "raw" data and lets you fine-tune the color later, on your computer. You can apply different color temperatures to the image, compare the results, and then have the computer apply one that you like without any

compromise to image quality. It's just like choosing a white balance setting at the time of exposure (only better, because you're looking at a 17" monitor, not a 2" LCD screen!).

If your camera has the ability to shoot in RAW format, it will include software to work with these images. Photoshop users can also work with RAW files right in Photoshop. Visit the Adobe site (*http://www.adobe.com*) for more information.

No matter which software you use, this method is as close as you can come to a true digital darkroom, and it provides you with maximum flexibility for processing your images. Shooting RAW images requires more work and processing time later, at the computer. But for situations in which you want absolute control over quality and final output, RAW is an excellent option.

Which is best for you? A common-sense approach would be to capture images at the highest JPEG setting for your "everyday" shooting, and take advantage of the RAW format for difficult lighting situations, or when you want to squeeze every drop of quality out of your picture-taking process.

Archive Images for Future Use

Digital images should be treated like any other important computer files: they should be archived and kept in a safe place. Most computers have built-in optical drives for burning compact discs and DVDs, both of which are reasonable archiving media. If you use optical discs for archiving, consider making two sets of backups—one for your home, and another to be kept in a remote location—just in case one set gets damaged.

Another archiving approach, and one that is easier to manage than using optical media, is to save your pictures to external hard drives. The advantages of external drives over optical

media are that they have greater capacity (250 GB and upward), have faster read/write times, and are easier to catalog.

If you really want to cover all the bases, back up your images onto two external hard drives and store them in different locations—one at home and another at the office. That way, not only are you protected if one drive fails, as hard drives sometimes do, but you also don't have to worry about losing your pictures if there is fire or water damage at one of the locations.

Some photographers like to use external hard drives for backing up at home, then save their most valuable images to optical media for storage at a remote location. This hybrid system strikes a good balance between convenience and reliability. And for the super fastidious (this is my category), think about a system that uses two sets of external hard drives in separate locations, plus one set of optical media in a third place. Does it sound a little over the top? Well, how important are your pictures to you?

Regardless of which media you use, when preparing to back up your photos, take a few minutes to figure out how you want to organize the files before you copy them to your backup media. Since digital cameras usually assign names such as *IMG_3298.JPG* to your pictures, you won't be able to go back and find those Paris shots by reading the filenames. Yet, you're probably not going to want to rename each picture individually, either.

Instead, give a descriptive name to the folder that contains images of a like kind, such as *Paris Trip 2002*. You can always browse the contents of the folder with an image browser once you're in the general vicinity.

No matter which method you embrace, the important thing is to have an orderly system and a regular backup routine. You already know how frustrating it is to look for an old picture

buried in a shoebox deep within your closet. Consider digital photography your second chance in life, and take advantage of your computer's ability to store and retrieve information.

> **NOTE**
>
> For more information on managing digital photographs, especially on a professional level, see *The DAM Book: Digital Asset Management for Photographers*, by Peter Krogh (O'Reilly).

Manage Movies Made with a Digital Camera

If you've followed the evolution of consumer digital cameras, you know that manufacturers have really improved these palm-sized devices' ability to capture high-quality video. The advantage for you is having just one device to take still pictures and capture life in motion as it breezes by.

In Chapter 2, I provided lots of tips for recording movies with your camera. The challenge is, what do you do with them after that? If you thought backing up your photographs was resource-intensive, just wait until you start creating those multi-megabyte movies.

External hard drives have become much more affordable and have tremendous storage capacity. I think they are the best solution for movie archiving. If you've created a robust archiving system with external drives for your photos, you should be able to adapt it to your movies as well.

Create easy-to-remember names for the folders you store your movies in, and give them their own location on the hard drive so you don't have photos and movies mixed in together. By spending the extra time to safely store this content, you'll ensure that others will be able to enjoy your movies for generations to come.

Stitch Together Video Clips into Short Movies

Often, the difference between an interesting home movie and one that's intolerable is editing. This applies to the video you capture with your digital camera as well. Chances are your digicam came bundled with software to help you edit your movies. If it didn't, or if you don't like that software, you can use QuickTime Pro and just a few simple commands to transform your video clips into short movies.

Many digital media fans are already familiar with QuickTime. The free player is available for Windows and Macintosh computers, and chances are you already have it on yours. If so, you can use it to watch the video snippets you capture with your digital camera.

You can purchase a registration key for $30 from the QuickTime web site (*http://www.apple.com/quicktime/*) that unlocks a number of additional powerful features, including:

Editing tools You can trim off excess footage, combine clips together, add soundtracks, and create titles for your movies.

Full-screen playback You can turn your computer into a movie theater that presents your videos in full-screen mode with a black background. It's very impressive.

Additional audio and video controls You can fine-tune playback by adjusting brightness, treble, and bass using the advanced controls.

I'm going to introduce you to two powerful editing techniques in QuickTime Pro. First you'll learn how to *trim* your snippets to cut off excess footage you don't need. Then you'll use the *Select*, *Copy*, and *Add* commands to combine your video clips into short movies. Here's how it works:

1. Upload all of your video snippets from your digital camera, and then open the two clips that you'd like to com-

bine into one short movie by double-clicking on their file icons or by using the Open command in QuickTime. Place them side by side.

2. Use the *Trim* command to snip off any unwanted footage at either end of your movie. Simply move the bottom triangles on the scrubber bar to the endpoints of the content you want to keep, as shown in Figure 3-20. The gray area will be kept, and the white area on the scrubber bar will be trimmed away. To make this happen, go to the Edit drop-down menu and select Trim. Repeat this process for both clips.

Figure 3-20. Trimming video clips is easy in QuickTime Pro. Drag the two bottom indicators to select the footage you want to keep. Then select Trim from the Edit menu at the top of the frame to discard the footage before and after those markers.

3. Now use Select, Copy, and Add to combine these short clips into a longer presentation. The procedure is similar to copying and pasting in a text document, but with a slight twist. Start by going to your first snippet and clicking on the far-right control button to move the scrubber head to the end of the clip, as shown in Figure 3-21. (You could manually drag the scrubber head there, but this way is faster.)

Figure 3-21. Move the scrubber head to the end of the first clip by clicking on the far-right control button.

Next, click on the second movie once to bring it forward. You're going to copy the content of this snippet and add it to the window on the left. Open the Edit drop-down menu and choose Select All, and then open the menu again and select Copy. That will put the selected video and audio on the clipboard.

Finally, click on the first window once to bring it forward, and choose Add from the Edit drop-down menu, as shown in Figure 3-22. The video you previously copied to the clipboard will be added to the end of your first snippet. Notice how the time designation has changed to reflect the addition of the second snippet (see Figure 3-23).

Figure 3-22. Choose "Add to Movie" from the Edit drop-down menu to add the footage you copied from your second video clip to the end of the first video clip.

Remember that I mentioned this procedure is like copying and pasting text, but with a twist? You could use the Paste command here, too, but doing so would *replace* the video in the lefthand window, instead of adding to it. That's the twist in QuickTime Pro.

If you want to combine more than two clips, you can keep adding snippets as described above until you have a complete movie. Always work from the beginning of the movie to the end, adding video clip after video clip, and be sure to trim your snippets before adding them to the movie.

Once you've combined your clips into one movie, go to the File menu and select Save As. Give your movie a new name, click the "Make movie self-contained" radio button, and then click the Save button. You now have a complete movie.

These simple editing maneuvers allow you to combine as many snippets as you want to build home movies. Keep in mind that you should use the same pixel dimensions, such as

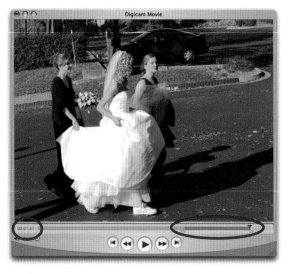

Figure 3-23. You have now combined the two video clips into one movie. Notice how the time designation has changed to reflect the additional footage.

320 × 240, for all of the clips that you'll use to create the final presentation. Otherwise, parts of your movie won't look right.

Regardless of which platform you create your movies on (Mac OS or Windows), they will play equally well on both Macs and PCs. You can also post your movies on your personal web site, to share with friends and family all over the world.

Where to Go from Here

Now it's time to shoot. The best thing about digital cameras is that you can take picture after picture without worrying about film processing costs—and the best way to learn the art and science of photography is to take lots of pictures.

Keep your eyes open, keep your camera steady, and, most importantly, enjoy!

Appendix

Use the following tables as a quick-reference guide for a variety of camera settings. For more detailed explanations of the data listed here, see Chapters 2 and 3.

Table A-1. Exposure compensation reference guide

Lighting situation	Recommended exposure compensation (via the scale setting)
Subject against a bright sky background (high clouds on sunny day)	Overexpose by 2 (+2.0); use fill flash if within 10 feet
Light object (white color), front lit	Overexpose by 1.5 (+1.5)
Subject against white sand or snow (e.g., person skiing)	Overexpose by 1.5 (+1.5)
Landscape scene dominated by bright, hazy sky	Overexpose by 1 (+1.0)
Fair-skinned subjects with bright front lighting	Overexpose by .5 (+.5)
Subject against green foliage in open sun (e.g., outdoor portrait with background trees and shrubs)	No compensation
Dark-skinned subjects with bright front lighting	Underexpose by .5 (−.5)
Brightly lit subject against dark background (e.g., theater lighting)	Underexpose by 1 (−1.0)
Dark object (black color), front lit	Underexpose by 1.5 (−1.5)

Table A-2. Flash mode settings

Situation	Recommended flash mode[a]
Outdoor portrait in open shade or sun	Fill flash (flash forced on)
Subject against bright background, such as hazy sky	Fill flash (flash forced on)
Weddings and other special events (both indoor and outdoor shooting)	Fill flash (flash forced on)
Subject in brightly lit evening scene, such as Times Square, New York, or Sunset Strip, Las Vegas	Slow-synchro flash (hold camera steady or use tripod)
Portrait against twilight sky, brightly lit monument, or building	Slow-synchro flash (hold camera steady or use tripod)
Portrait in brightly lit room where ambient lighting needs to be preserved	Slow-synchro flash (hold camera steady or use tripod)
Subject who typically blinks as flash fires	Red eye reduction flash (to eliminate recorded blinking)
Mood portrait by window, bright lamp, or other light source	Flash off (steady camera with tripod or other support)
Sporting event or outdoor concert when shooting from the stands	Flash off (steady camera with tripod or other support)

[a] On some point-and-shoot cameras, these flash settings are accessible only when you enable manual mode. Cameras typically ship in automatic mode, which limits the number of adjustments that the photographer can change. Refer to your owner's manual for more information.

Table A-3. White balance settings

Lighting condition	Recommended white balance setting
Sunny, outdoor conditions	Auto or Daylight
Open shade (e.g., under a tree), indoor portraits by window light, or when flash is on indoors	Cloudy (add fill flash when possible)
Snow setting, bluish winter light, or when overall light balance is too "cool"	Cloudy
Indoors with flash off, when dominant light source is tungsten light	Tungsten
Outdoors at sunset or sunrise, when light is too "warm"	Tungsten
Indoors, when dominant light source is fluorescent tubes	Fluorescent

Table A-4. Camera modes with explanations

Camera mode[a]	Explanation
Programmed autoexposure (P)	Camera sets both aperture and shutter speed. Good for general photography.
Shutter priority/ timed value (S or Tv)	Photographer sets shutter speed and camera sets corresponding aperture. Best for action, sports, or running water photography.
Aperture priority/ aperture value (Av)	Photographer sets aperture and camera sets corresponding shutter speed. Best for landscape photography or any situation that requires depth of field control.
Manual (M)	Photographer sets both aperture and shutter speed. Advanced mode for those with an understanding of photography.

Table A-4. Camera modes with explanations (continued)

Camera mode[a]	Explanation
Movie	Camera records video segments and saves them as QuickTime, AVI, or MPEG files. Some models also record sound to accompany the video.
Panorama	Camera designates a sequence of shots to be later "stitched together" to create one image with a wide perspective. Some cameras give you onscreen assistance to line up the sequence.
Nighttime	Allows for longer shutter speeds (even when the flash is enabled) to enable photography in low ambient light, such as at sunset or for brightly lit interiors. A tripod should be used to help steady the camera when using this mode.

[a] Your camera may have all, some, or only a couple of these modes available. Typically, aperture priority, shutter priority, and manual modes are available only on advanced models.

Table A-5. Metering modes with explanations

Metering mode[a]	Explanation
Evaluative metering	Camera divides viewing area into "segments" and evaluates each area alone and in combination with others. End result is very accurate overall exposure for most scenes. Good choice for general photography.
Spot metering	Camera reads only center portion of viewing area, usually within the center brackets or crosshairs. Good choice for situations that require precise exposure control on a particular element in the scene. Most popular use is to correctly meter a person's face in difficult lighting situations.
Center-weighted metering	Camera reads entire viewfinder area, but with more emphasis placed on central portion of scene. Typically used for landscape and general photography. Evaluative metering is usually preferred over center-weighted metering.

[a] Many point-and-shoot cameras offer only one metering mode—usually center-weighted or evaluative. Intermediate and advanced models usually include spot metering, too.

Table A-6. Exposure starting points for sunset and astrophotography[a]

Subject	ISO speed	Aperture (f-stop)	Shutter speed
Sunset (point at sky without sun shining in viewfinder)	100	Programmed autoexposure	Programmed autoexposure
Full moon	100	f-8	1/250th–1/500th of a second
Quarter moon	100	f-5.6	1/125th–1/250th of a second
Total lunar eclipse	200	f-2.8	2 seconds (use tripod)
Half lunar eclipse	200	f-4	1 second (use tripod)
Aurora borealis	200	f-2.8	2–30 seconds, depending on intensity (use tripod)
Star trails	100	f-4	10 minutes or longer (use tripod)
Meteors	100	f-5.6	30 minutes or longer (use tripod)

a The settings in this table should only serve as starting points for astrophotography. Allow ample time for testing with your equipment and conditions for optimum results.

Table A-7. Megapixels to print size reference

Camera type	2 MP	3 MP	4 MP	6.3 MP	8 MP
Photo-quality	5" × 7"	8" × 10"	10" × 12"	11" × 14"	14" × 16"
Acceptable	8" × 10"	10" × 12"	11" × 14"	14" × 16"	16" × 20"

Table A-8. Number of pictures to capacity of memory card reference[a]

Camera resolution	1600 × 1200 (2 MP)	2048 × 1536 (3.3 MP)	2272 × 1704 (4 MP)	2560 × 1920 (5 MP)	3072 × 2048 (6.3 MP)	3456 x 2305 (8 MP)
Card capacity	How many pictures	How many pictures	How many pictures	How many pictures	How many pictures	How many pictures
32 MB	20	17	15	13	11	8
64 MB	40	35	30	26	23	17
128 MB	82	71	61	54	48	36
256 MB	180	143	123	110	101	72
512 MB	370	287	247	221	203	145
1 GB	727	575	494	443	409	293
2 GB	1,456	1,150	989	887	820	588
4 GB	2,910	2,302	1,980	1,776	1,642	1,178

[a] The number of pictures listed for each memory card size in this table is for images saved at the highest quality setting in the JPEG format. You can "squeeze" more pictures onto a card by lowering the quality setting, but this is not recommended. Different camera brands may produce results slightly different from those shown here.

Table A-9. Color temperature chart in Kelvin

Degrees Kelvin	Type of light source
1700–1800K	Match flame
1800–2200K	Dawn, dusk, candle flame
2400–2600K	40W incandescent bulb
2800–3000K	100W incandescent bulb
3200–3400K	500W photoflood bulb, quartz bulb
4200K	Sun at 20 degrees altitude, cool white fluorescent bulb
5400K	Sun at noon
5500K	Photographic daylight
5500–6000K	Hazy sun, photo electronic flash, HMI lamp, neon bulb
6500 – 7000K	Bright sun, daylight fluorescent bulb
8000–9000K	Open shade outdoors, overcast sky
9000–10000K	North light, skylight window

Index

Better than e-books

Buy *Digital Photography Pocket Guide* and access
the digital edition FREE on Safari for 45 days.

Go to www.oreilly.com/go/safarienabled and type
in coupon code JYGU-KZZE-TB1P-WDE2-QCVZ

Search
thousands of
top tech books

Download
whole chapters

Cut and Paste
code examples

Find
answers fast

Related Titles from O'Reilly

Digital Media

Acrobat CS2 Workflow

Adobe InDesign CS2
One-on-One

Adobe Encore DVD:
In the Studio

Adobe Photoshop CS2
One-on-One

Assembling Panoramic Photos:
A Designer's Notebook

Creating Photomontages with
Photoshop: A Designer's
Notebook

Commercial Photoshop
Retouching: In the Studio

The DAM Book: Digital Asset
Management for Photographers

Digital Photography:
Expert Techniques

Digital Photography Hacks

Digital Photography Pocket
Guide, *3rd Edition*

Digital Video Pocket Guide

Digital Video Hacks

DV Filmmaking: From Start to
Finish

DVD Studio Pro 3: In the Studio

GarageBand 2: The Missing
Manual, *2nd Edition*

GoLive CS2 Workflow

Home Theater Hacks

Illustrations with Photoshop:
A Designer's Notebook

Illustrator CS2 Workflow

InDesign CS2 Workflow

iMovie HD & iDVD 5:
The Missing Manual

iPhoto 5: The Missing Manual,
4th Edition

iPod & iTunes Hacks

iPod & iTunes: The Missing
Manual, *3rd Edition*

iPod Fan Book

iPod Playlists

iPod Shuffle Fan Book

Photo Retouching with
Photoshop: A Designer's
Notebook

Photoshop CS2 Workflow

Photoshop Elements 3 for
Windows One-on-One

Photoshop Elements 3:
The Missing Manual

Photoshop Photo Effects
Cookbook

Photoshop Raw

Photoshop Retouching
Cookbook for Digital
Photographers

Windows Media Hacks

O'REILLY®

Our books are available at most retail and online bookstores.

To order direct: 1-800-998-9938 • *order@oreilly.com* • *www.oreilly.com*

Online editions of most O'Reilly titles are available by subscription at *safari.oreilly.com*

Keep in touch with O'Reilly

1. Download examples from our books

To find example files for a book, go to:

www.oreilly.com/catalog

select the book, and follow the "Examples" link.

2. Register your O'Reilly books

Register your book at *register.oreilly.com*

Why register your books? Once you've registered your O'Reilly books you can:

- Win O'Reilly books, T-shirts or discount coupons in our monthly drawing.
- Get special offers available only to registered O'Reilly customers.
- Get catalogs announcing new books (US and UK only).
- Get email notification of new editions of the O'Reilly books you own.

3. Join our email lists

Sign up to get topic-specific email announcements of new books and conferences, special offers, and O'Reilly Network technology newsletters at:

elists.oreilly.com

It's easy to customize your free elists subscription so you'll get exactly the O'Reilly news you want.

4. Get the latest news, tips, and tools

www.oreilly.com

- "Top 100 Sites on the Web"
 —PC Magazine
- CIO Magazine's Web Business 50 Awards

Our web site contains a library of comprehensive product information (including book excerpts and tables of contents), downloadable software, background articles, interviews with technology leaders, links to relevant sites, book cover art, and more.

5. Work for O'Reilly

Check out our web site for current employment opportunities:

jobs.oreilly.com

6. Contact us

O'Reilly & Associates
1005 Gravenstein Hwy North
Sebastopol, CA 95472 USA

TEL: 707-827-7000 or 800-998-9938
(6am to 5pm PST)

FAX: 707-829-0104

order@oreilly.com
For answers to problems regarding your order or our products.
To place a book order online, visit:
www.oreilly.com/order_new

catalog@oreilly.com
To request a copy of our latest catalog.

booktech@oreilly.com
For book content technical questions or corrections.

corporate@oreilly.com
For educational, library, government, and corporate sales.

proposals@oreilly.com
To submit new book proposals to our editors and product managers.

international@oreilly.com
For information about our international distributors or translation queries. For a list of our distributors outside of North America check out:
international.oreilly.com/distributors.html

adoption@oreilly.com
For information about academic use of O'Reilly books, visit:
academic.oreilly.com

O'REILLY®

Our books are available at most retail and online bookstores.
To order direct: 1-800-998-9938 • *order@oreilly.com* • *www.oreilly.com*
Online editions of most O'Reilly titles are available by subscription at *safari.oreilly.com*